ALEXANDER CALDER AND HIS MAGICAL MOBILES

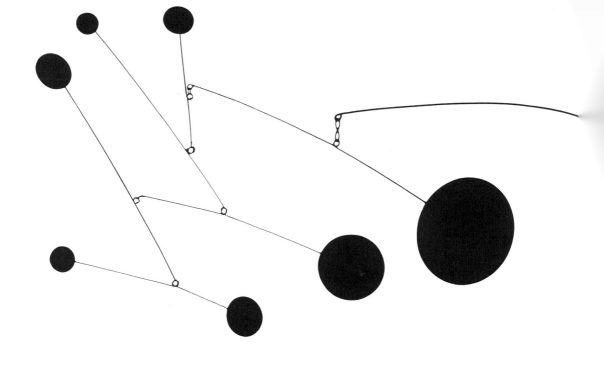

Hudson Hills Press, Inc. New York
in association with the Whitney Museum of American Art

ALEXANDER CALDER AND HIS MAGICAL MOBILES

Jean Lipman
with Margaret Aspinwall

The mobile illustrated on the cover and title page is *Dots and Dashes,* 1959. This mobile is also illustrated at the upper corner of every left-hand page from page 48 to the end of the book. If you flip these pages from back to front, you will see how *Dots and Dashes* looks when it is in motion.

The quotations that appear with some of the illustrations are Calder's.

Published in the United States by Hudson Hills Press, Inc., Suite 1308, 230 Fifth Avenue, New York, NY 10001-7704.
Distributed in the United States, its territories and possessions, Canada, Mexico, and Central and South America by National Book Network, Inc.
Distributed in the United Kingdom and Eire by Shaunagh Heneage Distribution.
Distributed in Japan by Yohan (Western Publications Distribution Agency).

For Hudson Hills Press
Editor and Publisher: Paul Anbinder
Copyeditor: Janet Finnie
Designer: Vincent J. Schifano
Composition: Francis-Dreher Co.
Manufactured in Japan by Toppan Printing Co.

For the Whitney Museum of American Art
Head, publications: Doris Palca

Library of Congress Cataloguing in Publication Data

Lipman, Jean, date
Alexander Calder and his magical mobiles.

Bibliography:
Summary: Describes the life and career of twentieth-century artist Alexander Calder and includes illustrations of a variety of his works and a guide to his sculptures in museums and public spaces.

1. Calder, Alexander, 1898–1976—Juvenile Literature.
2. Artists—United States—Biography—Juvenile literature. [1. Calder, Alexander. 1898–1976.
2. Artists] I. Aspinwall, Margaret, 1945–
II. Title.
N6537.C33L57 709'.2'4 [B] [92] 81-1811
ISBN 0-933920-17-2 AACR2

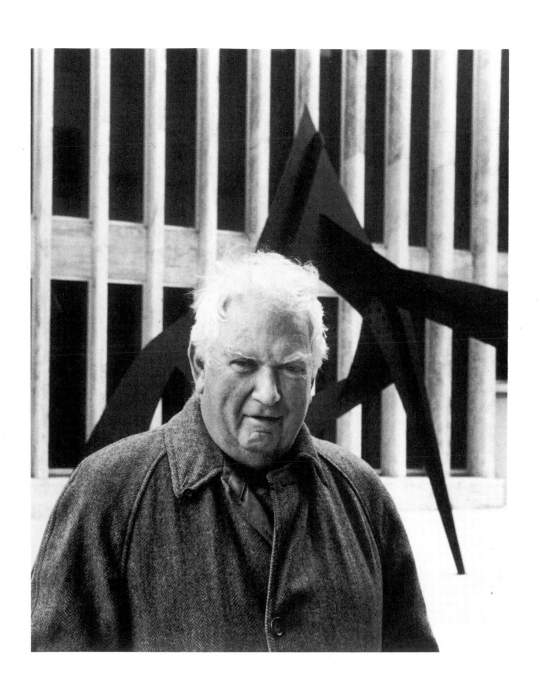

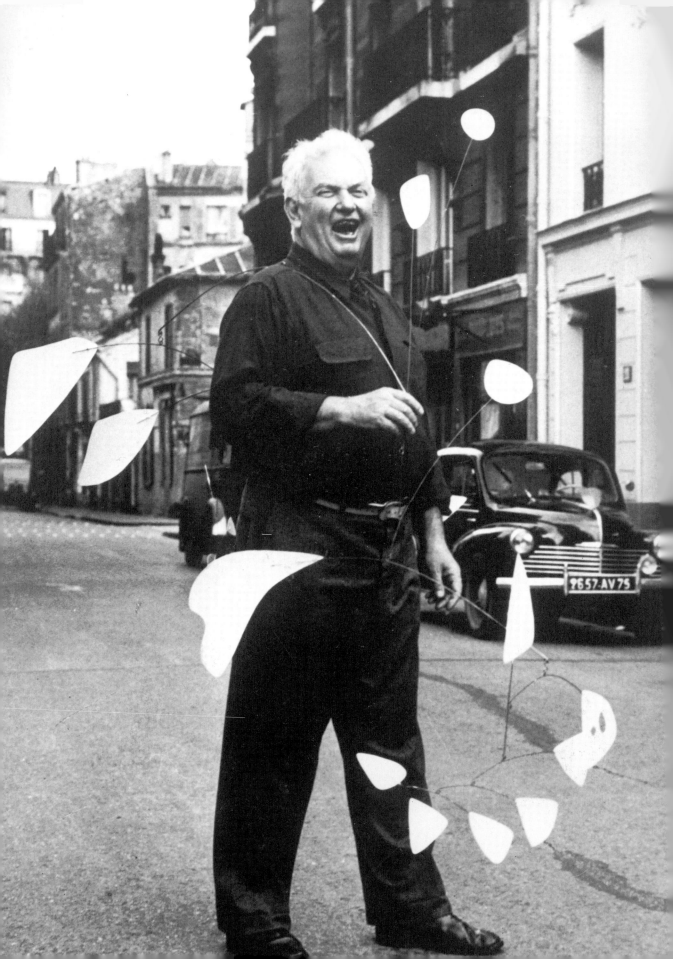

CONTENTS

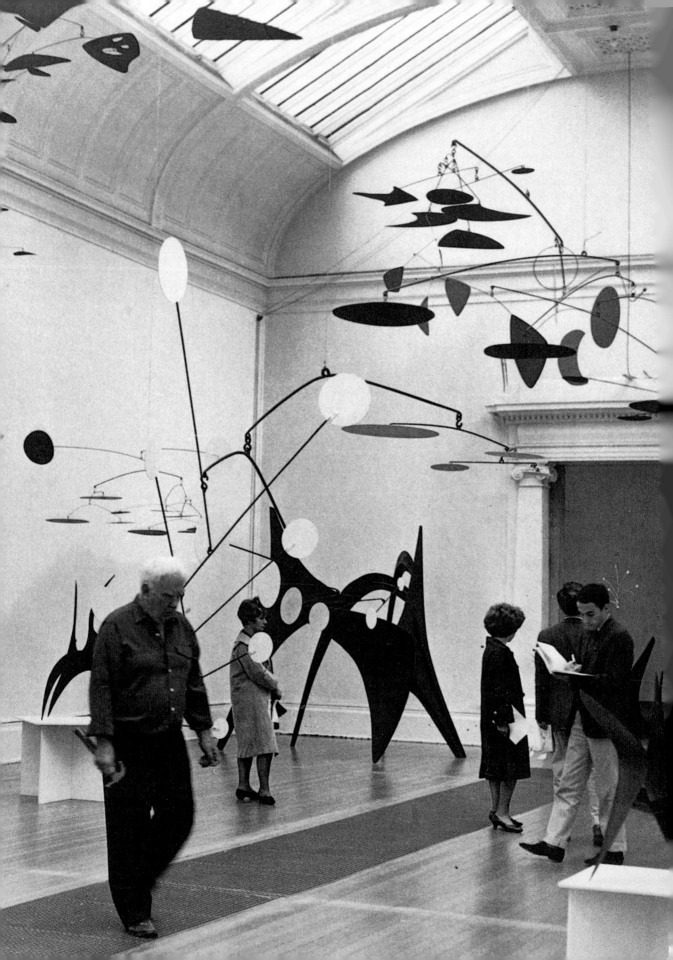

For Ben and Tim,
the third generation of Lipmans
to admire and live with
the works of Sandy Calder

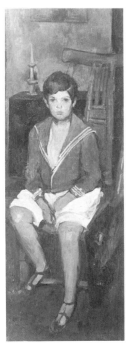

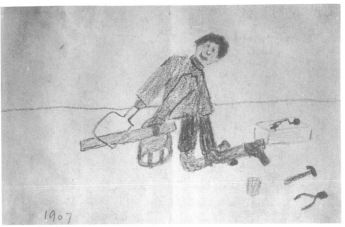

Sandy's self-portrait done at age nine.

PORTRAIT OF SANDY
at thirteen by his mother,
Nanette Calder.

LAUGHING BOY, about 1910,
a portrait of twelve-year-old
Sandy by his father,
Alexander Stirling Calder.
Bronze cast made in 1975 for
the Whitney Museum.

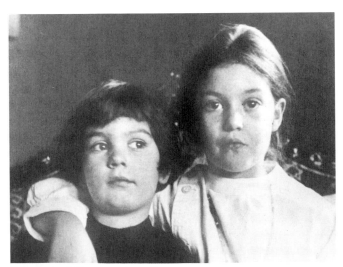

Sandy and Peggy when they were
seven and nine years old.

SANDY CALDER'S LONG & HAPPY LIFE

Alexander Calder was a big, jolly, playful man, called Sandy by his friends. He was my friend for forty years and the artist of our time whom I most admire. After reading this book, I hope you will feel that you know him too as the delightful person he was, and will be more interested in his works when you see them, especially his mobiles.

He was born in 1898 in Lawnton, Pennsylvania, now a part of Philadelphia. There were famous artists in his family. His mother was a painter, and his grandfather and father were sculptors. It turned out that Sandy became the greatest one of all.

Sandy and his sister, Peggy, who was two years older, were best friends all their lives. While they were children living in Arizona, California, and New York State, they made their own toys and games. When Sandy was only five years old, he made little wood and wire people and animals, and at eight he made jewelry for Peggy's doll, Princess Thomasine, out of little beads mounted on bits of copper wire that telephone repairmen had left in the street. When he was a famous artist he was still making jewelry — for his wife and friends and for Peggy.

Sandy always had a workshop. His parents encouraged him to make things himself, and before he was ten Peggy gave him his first pair of pliers for his first workshop. She saved up her weekly allowance of five cents until she had the seventy cents she needed for the pliers. Sandy drew a picture of himself at work when he was nine years old. You can see him sawing a piece of wood, and a drill, hammer, and Peggy's pliers on the floor.

Sandy's workshops were all different: one was a tent with a wooden floor, and several others were in the cellars of the Calders' houses. Later in his life his workshops in France and in Connecticut were separate buildings big enough for his huge sculptures. His Connecticut workshop always looked as though everything was piled up in a careless mess, but Sandy knew where each thing was and could pick up just what he needed,

even if it was buried under what looked like a mound of junk. He didn't like to throw away the bits of scrap left over from cutting pieces of his sculptures; he said, "You can always find new ways to use scrap metal so it isn't scrap anymore." His *Portrait of a Young Man* (page 71) is one of the works he made from scrap metal.

As a child, he assembled so large a collection of carefully chosen and treasured scraps that his mother gave him a tall chest of drawers to store them in. Later in his life he enjoyed visiting junkyards, and once advised Peggy to look there for something that could be an interesting substitute for the andirons she had told him she needed. One of his small works is titled *Gothic Construction from Scraps;* this was one that Sandy never wanted to sell and kept for himself. He saved all sorts of scraps, bits of china plates and pieces of broken glass and lots of other things that he thought he might want to use. The mobile called *Fish* (page 46) was made with wire and pieces of broken glass.

Sandy always liked to think of new contraptions. In the fourth grade he made a blotting pad to hang on the side of his desk, and he thought up things like a two-pronged fork made of wire with a trigger ejector to kill garden slugs. Peggy described

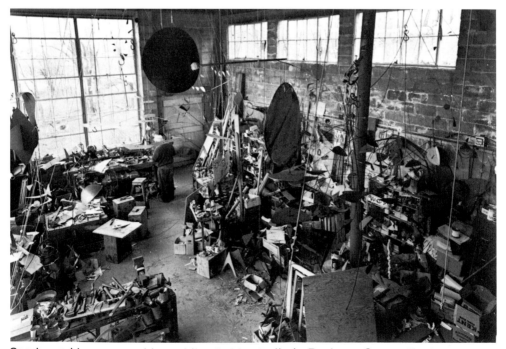

Sandy working among his mobiles in his studio in Roxbury, Connecticut.

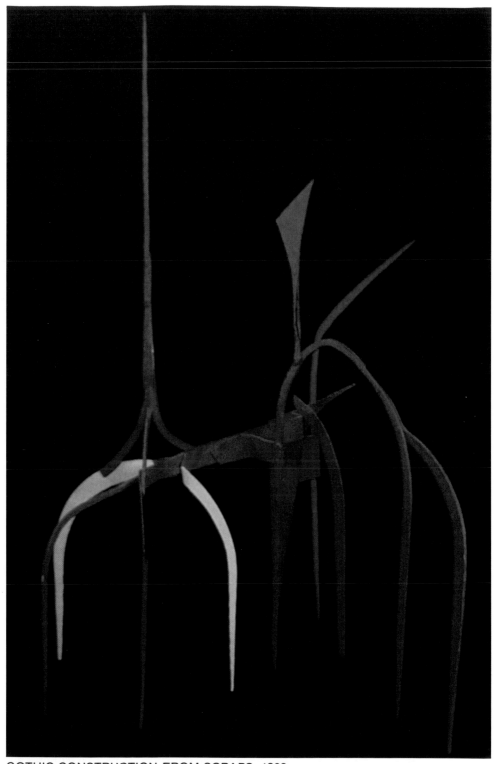

GOTHIC CONSTRUCTION FROM SCRAPS, 1939.
"It is the apparent accident to regularity which the artist actually controls that makes or mars a work."

his bedroom when he was in elementary school: It was "a maze of strings; they pulled up shades and lowered them, pulled the casement windows closed, turned the lights on and off." When he was in his twenties, and had taken a job as a fireman on a ship, he invented several useful things: one was a shaped piece of metal, a baffle, to direct breezes into the hot boiler room where he worked.

It was on this sea voyage that Sandy first became interested in thinking about our whole universe. You'll find suns and moons and stars in some of his best drawings and paintings, even in rug and wallpaper designs; and they are an important part of many of his sculptures. Several are titled *Universe;* the largest one is shown on page 45. The planet is his subject in other things too, from enormous stage sets to small rugs. Sandy liked to talk about that time when he was sailing on the ship *H. F. Alexander.* The following quotation is from a wonderful book about his life and work, *Calder: An Autobiography with Pictures,* for which his son-in-law, Jean Davidson, wrote down everything exactly as Sandy told it: "It was early one morning on a calm sea, off Guatemala, when over my couch — a coil of rope — I saw the beginning of a fiery red sunrise on one side and the moon looking like a silver coin on the other. Of the whole trip this impressed me most of all; it left me with a lasting sensation of the solar system."

Sandy once told his mother that the first inspiration he ever had was the planetary system — the sun, moon, and stars. His mother said, "But you don't know anything about the stars." And Sandy replied, "No, I don't, but you can have an idea of what they're like without shaking hands with them." However, Peggy remembers that, when Sandy was ten, their mother got a book called *The Friendly Stars* and helped them locate planets by following its instructions. The movement of the sun and moon across the skies was what especially interested him. He said that he thought there was no better inspiration for his work than the universe, although he added that a *part* of the universe was his model, as the whole thing "is rather a large model to work from." He said another time, "I work from a large live model."

Motion — action — was the most important thing in all of Sandy's work. Peggy remembers races of chariots pulled by

horned toads, in Arizona when she and Sandy were children; they dangled flies to encourage the toads, harnessed with threads, to pull Sandy's matchbox carts. Then in California, when Sandy was ten, they saw real four-horse chariot races and made chariots out of old orange crates for neighborhood races. Much later Sandy made a toy Roman chariot, featured a chariot race in his miniature Circus, and made a mobile titled *The Chariot.*

As a child Sandy loved riding on trains and, in San Francisco, on the cable cars. Later he was fascinated with the action of the animals and acrobats and moving spotlights in the circus in New York. He soon made his own toy Circus, as well as some animal "action toys" for a toy company. Sandy made drawings and paintings of animals, and wood and bronze and wire animals, and even jewelry and mobiles in animal shapes all

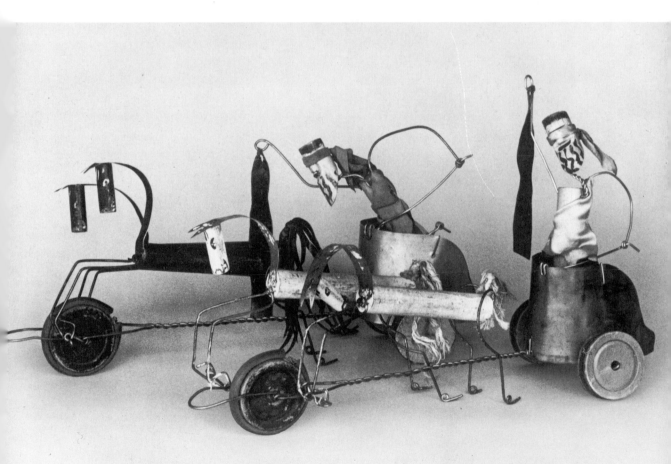

CHARIOTEERS from the Circus, 1926–31.

the time he worked as an artist—for more than fifty years. His first book was *Animal Sketching;* it was made up of lively drawings of animals he saw in the zoo. One page started with the words "Animals—Action" and went on to say that "these two words go hand in hand in art."

His mobiles, of course, were his most important action works, and they are now the American sculpture most admired by people all over the world. Sandy Calder invented and perfected an art of motion. The major part of this book is about the magical mobiles he made. Other works he made were related to the mobiles, and were also active in various ways—fountains and jet planes and a racing car, and moving stage sets with mobiles in them, and mobile jewelry, and sculpture in wood, bronze and wire, and many other lively things. You will also see pictures of the stabiles (so named by the famous sculptor Jean Arp because they were stable—didn't move) and drawings, paintings, tapestries, rugs, and wallpaper.

After Sandy graduated from high school he decided to become an engineer and went to study at Stevens Institute of Technology in New Jersey. He graduated with a degree in Mechanical Engineering. After having various jobs in engineering and other fields, he found that what he really wanted to be was an artist, so he studied at the Art Students League in New York

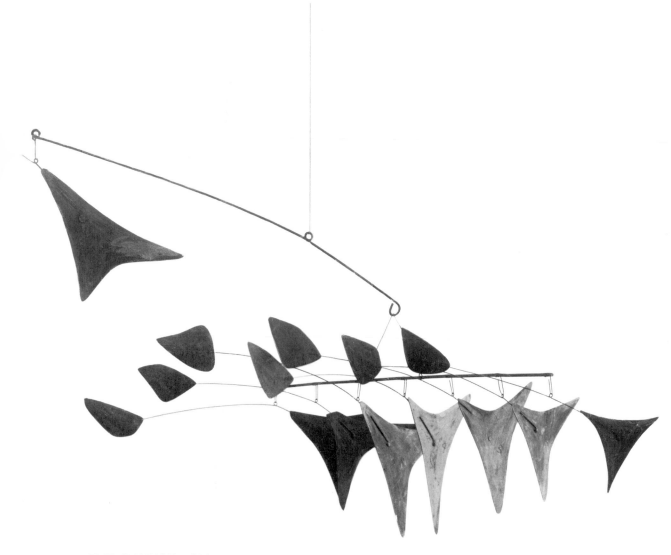

THE CHARIOT, 1961.

for several years. He was still an engineer, and that was always a very important part of his art. It's easy to see how his engineering training had a great deal to do with his work as an artist.

A classmate of his at Stevens wrote me a letter to describe Sandy in his college days. He was always happy, joking, grinning, giggling—and he was a brilliant student interested in new approaches to things. He was, his friend said, "one of the best-natured fellows there is," and added, "I never heard him say

an unkind word about anyone." Klaus Perls, whose gallery sold Sandy's work in New York, described him as "a man of one hundred per cent goodwill." The great artist Joan Miró, who was Sandy's close friend, said that he had "a heart as big as Niagara."

Sandy was never, in all his long life, unhappy. He himself said that he had "a big advantage" as he was "inclined to be happy by nature." Once a magazine reporter asked him if he ever experienced sadness, and he answered, "No, I don't have the time." You can see from his work that the pure pleasure of combining interesting shapes and bright colors and lively motion is a great deal of what it's about, and that's why it gives us instant pleasure to look at it. He wrote in a letter to his grandniece: "Above all, I feel art should be happy." Very few works of art can make us feel light-hearted the way Sandy Calder's do.

His wife, Louisa, and his daughters, Mary and Sandra, and his four grandchildren all helped to make him happy. Sandra is an artist now, like her father, grandfather, grandmother, and great-grandfather. She does wonderful bright-colored drawings for the children's books she writes about imaginary animals.

In 1925, while Sandy was studying drawing and painting at the Art Students League, he did some sketches of the Ringling Brothers and Barnum & Bailey Circus for the *National Police Gazette.* He said, "I went to the circus. I spent two full weeks there practically every day and night." This was very important in his career, the beginning of his lifelong interest in the circus.

The following year he left for Paris, where he began to make the miniature Circus whose performances made him famous in the Parisian art world. He also made his first wire portraits, which were a natural development from his Circus figures. Paris was the center of the art world, where many painters and sculptors were trying out exciting new ideas. Some of them heard about the Circus and came to visit Sandy to see his performances. Many of them were, from that time on, friends for the rest of his life. He had hundreds of friends, and quite a few of them were famous people — painters and sculptors and architects, and writers, actors, filmmakers, stage designers, and musicians — from all over the world.

After he came back to America, he continued giving his Circus performances and went on painting. While he was painting he was also becoming interested in sculpture. He was both a painter and a sculptor for the rest of his life, living and working both in France and in America. (His homes were in Roxbury, Connecticut, and Saché, France. You will find a number of his works with French titles, even some like *Effet du Japonais,* page 49, that he made in Connecticut.) He created a lot of other things besides paintings and sculpture, and for almost everything he made, *motion* was the most important part of the idea. Even before he thought of making mobiles, he said he "felt that art was too static to reflect our world of movement."

Sandy Calder lived in fine spirits and good health till he died suddenly in 1976. He was seventy-eight years old, and he had just finished designing the great mobile for the National Gallery of Art in Washington, shown on page 59. He was also planning and working on many other things at the same time, as he always was. He had a very long and unusually full and happy life, and the thousands of things he created have added to the happiness of millions of people.

Just after Sandy died, his family and a group of his friends met at the Whitney Museum of American Art in New York to hear a few of his closest friends talk about him and his life and his work. There was an exhibition there, *Calder's Universe,* of all the kinds of work he had done during his life. His friend James Johnson Sweeney said, "The dancer is gone but the dance remains." We all looked up at the gay mobiles swinging over our heads, and we remembered that Sandy had once said that "a mobile is a piece of poetry that dances with the joy of life."

Sandy Calder's mobiles now dance all over the world.

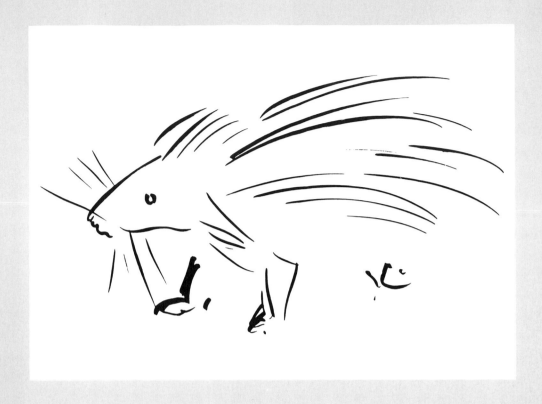

PORCUPINE, PELICAN, MONKEY, zoo drawings, 1925–26.

BEFORE THE FAMOUS MOBILES

ANIMAL SKETCHING

Sandy Calder's first book was called *Animal Sketching.* In 1925 and 1926, when he was living in New York, he spent a great many days sketching at the Central Park and Bronx zoos. He had always been fascinated with the way things moved — cable cars, motors, people, and animals. He wanted to draw animals to show how they looked in motion, and to do it with as few lines as possible.

He drew in India ink with a brush instead of a pen for these quick sketches; that's the way old-time Japanese artists used to work. There are sixty-two pages in this little book, and a few years ago a package of more of the same kind of drawings was found. Sandy had put it away and forgotten all about it. There were 248 drawings that he had done at zoos fifty years earlier, most of which had not been used for the book. The porcupine, monkey, and pelican you see here are from this rediscovered package.

Sandy said later that he "seemed to have a knack for doing it with a single line." Peggy (whose full name is now Margaret Calder Hayes) wrote in her book, *Three Alexander Calders,* that as children "Sandy and I worked out a formula for drawing birds: one uninterrupted line flowed around the entire body, including its journey to the tail (a series of loops) and the wings (another series of loops). Only the eyes and feet had to be added." See how few lines Sandy needed to do a jumping monkey when he first began to draw. It looks easy, but if you try to sketch a lively animal in six lines, you'll see that it isn't.

When you look at the wire sculptures and the wirelike pen drawings, it will be clear that one line that goes on a long way without stopping was something that continued to interest Sandy.

ACTION TOYS

Sandy enjoyed making and playing with toys when he was a child, and when he became a famous artist he liked making toys as much as ever. Almost all his serious works were playful in some way. He said, "I want to make things that are fun to look at."

Sandy and Peggy had especially liked animal toys. They had several Noah's Arks and made all kinds of active animals. Peggy still has one of Sandy's first toys, a group of carved wood chickens that wobble back and forth on wire legs.

When Sandy was a young man living in Paris, he began making toys with wire, wood, tin, and leather that he hoped to sell. A friend later remembered how, at that time, Sandy was working on a very funny and astonishing action toy — a bird that was having a hard time pulling a worm out of the ground. Back in the United States, Sandy did sell a group of toys to a door-manufacturing company in Wisconsin that also made some "Toddler Toys." He said that this Gould Company used plywood and thick chunks of wood, and that he "took their scraps and made various toys — a rowboat, a kangaroo, a kicking cow, ducks, a skating bear." Others were a swimming fish, a feeding pelican, and a goring bull. And you can imagine from the photograph of his kangaroo model how it hopped along.

KANGAROO pull-toy, 1927.

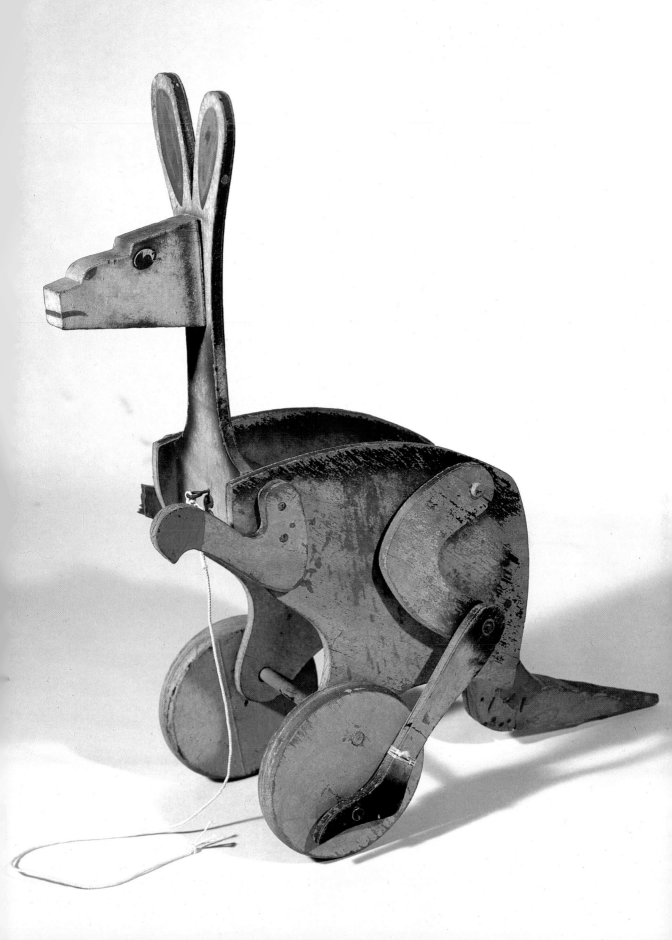

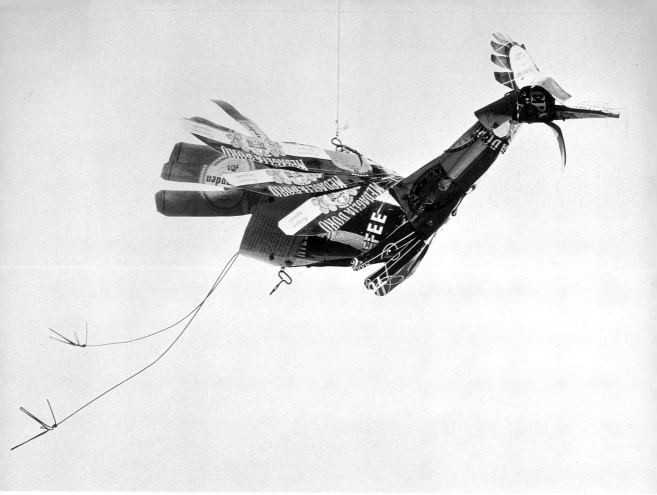

LE COQ DE SACHÉ, 1965. "I want to make things that are fun to look at."

Sandy made toys for all the children in his family out of tin cans, wire, corks, bits of leather — anything that came handy. His daughters particularly liked a dollhouse that had elevators running between the floors for the dolls that lived in the house. He once made a mobile of red and blue balls for a friend's cat to bat around, and a mask for his own cat that made her into a cow. He also made wonderful toys for grownups, like his flying birds made from flattened and cut tin cans.

Sandy's first action toys gave him all the ideas he needed for how to make the Circus. The action of the toys and the Circus people and animals was not really very different from the action of the playful mobiles. The toys and the Circus performers are simple, and plain fun to watch, but there is beauty and magic in the way they move. There is the same mixture of fun and lovely magic in the motion of the mobiles.

THE CIRCUS

After Sandy saw the Ringling Brothers and Barnum & Bailey Circus in New York for the first time — he was twenty-seven years old then — he went back almost every day and night for two weeks. The *National Police Gazette* paid him twenty dollars for a drawing of the circus. Then he started making his own toy Circus. Years later he said, "I always loved the circus so I decided to make a circus just for the fun of it." He and Peggy had seen a small circus when they were children, and had reconstructed some of the acts they liked. Sandy had also made a little circus with their Noah's Ark animals and some of their jointed toy animals and clowns.

For his now-famous Circus, he kept adding new performers over a five-year period from 1926 to 1931. He ended up with a troupe of fifty-five people and animals, none of them more than fourteen inches high; when they were packed to take somewhere for a performance they fit into five suitcases. They are all in the Whitney Museum in New York now, where Sandy set them up in a case on the main floor so they can be seen by everybody who comes to the museum. There's also a delightful nineteen-minute movie shown three times a day, *Calder's Circus,* in which Sandy gives his last performance, at his home in France, the same way he and his troupe had performed for thirty years in Europe and the United States. Sandy is the ringmaster, with his Circus puppet, Monsieur Loyal, announcing the acts in French. Louisa manages the phonograph music.

The performers are funny, lively figures. Like the clown you see here, they are put together out of such things as bits of wood, metal, cloth, paper, leather, string, wool, bottle caps, corks, and all sorts of other surprising materials, but they seem to be as alive as real people and animals in their acts. Rigoulot, the weight lifter, slowly lifts his barbell above his shoulders as if the tin balls weighed hundreds of pounds. Acrobats swing through the air and nimbly catch each other by their tiny claw hands. There are a spear thrower and a sword swallower, a tightrope performer, a man on stilts, a jazz singer, Japanese wrestlers, a chariot race, and lots of other acts.

There are all the performing circus animals you'd expect to see too. The elephant blows water out of its rubber-tube trunk. The lion leaps from its cage and is shot when its keeper

becomes afraid that he's in real danger. A pair of seals hit a ball back and forth. Sandy roars for the lion and barks for the seals.

Sandy did dozens of drawings and paintings of circus scenes. All through his life animals and the circus were his favorite subjects. If you look now at some of the pictures of mobiles on pages 46–61, you might think (as I do) that the lively acrobatic motion and balance, and the suspense and surprise and playfulness of the mobiles, really grew right out of his toy Circus.

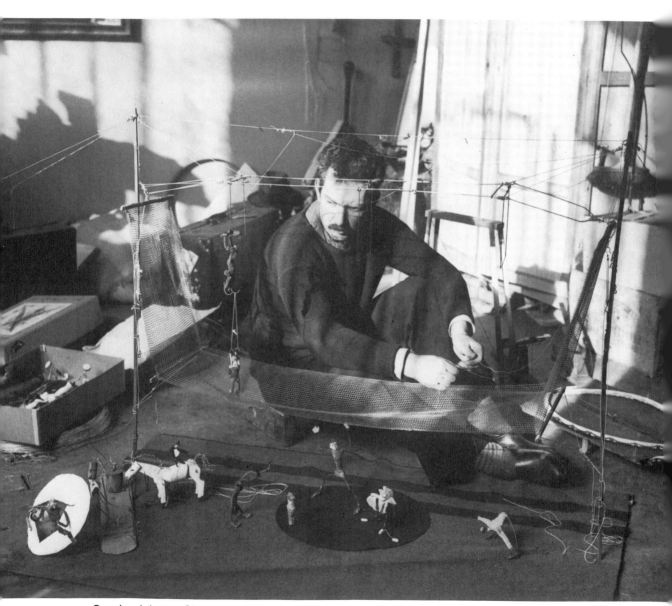

Sandy giving a Circus performance, 1929.

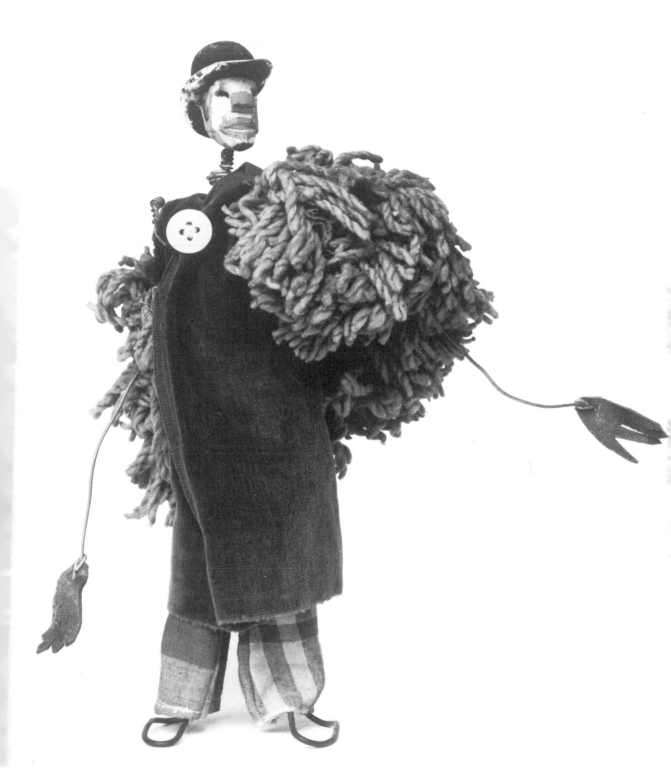

CLOWN from the Circus, 1926–31.

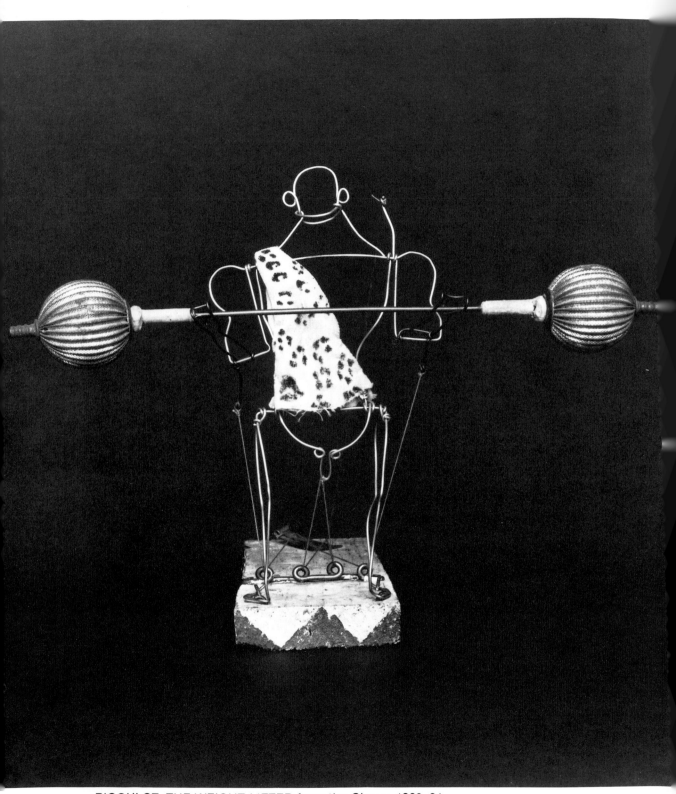

RIGOULOT, THE WEIGHT LIFTER from the Circus, 1926–31.

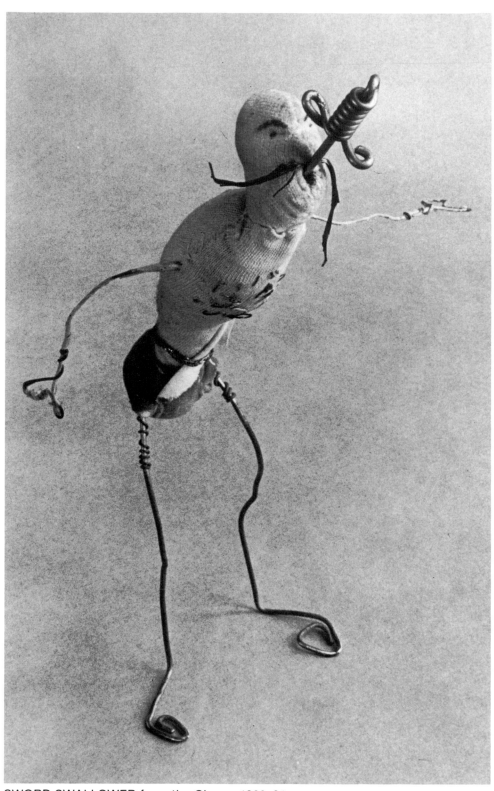

SWORD SWALLOWER from the Circus, 1926-31.

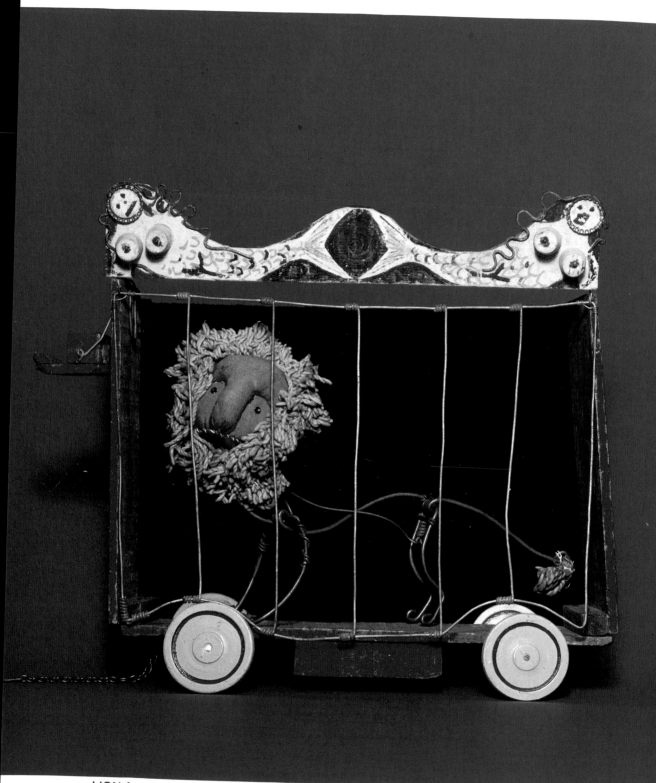

LION from the Circus, 1926–31.

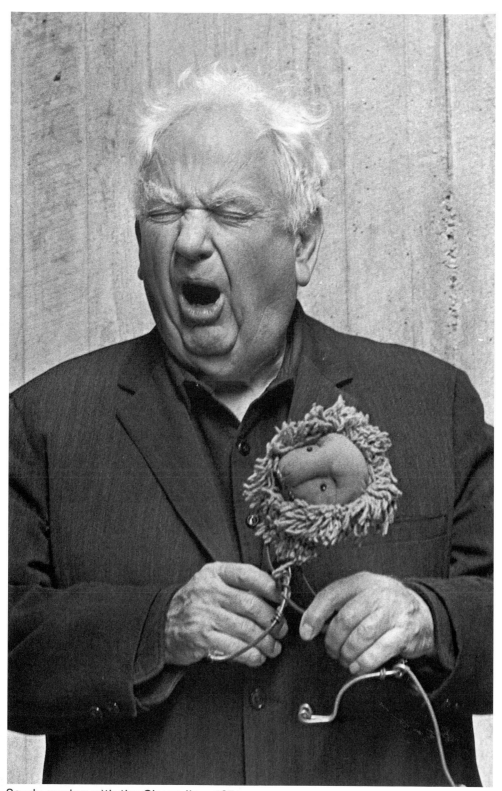

Sandy roaring with the Circus lion, 1971.

WOOD, BRONZE, AND WIRE WORKS

WOOD

The velvet cow that Sandy stuffed and sewed up for his Circus looks surprisingly like the cow he chiseled out of an interestingly grained and shaped tree limb. The materials he used always had a lot to do with what he decided to make. He once said, "I feel an artist should go about his work simply with great respect for his materials." When he was asked to carve more cows like the first, to sell, he turned down the offer. "That piece of wood turned out to be a cow," he said, "but the next one might be a cat. How do I know?"

Sandy was easygoing and obliging about everything except his work. He knew exactly how he wanted to do things and how he expected his objects to look, and he was unwilling to compromise. The architect Frank Lloyd Wright, who had built the Guggenheim Museum in New York, heard that Calder was

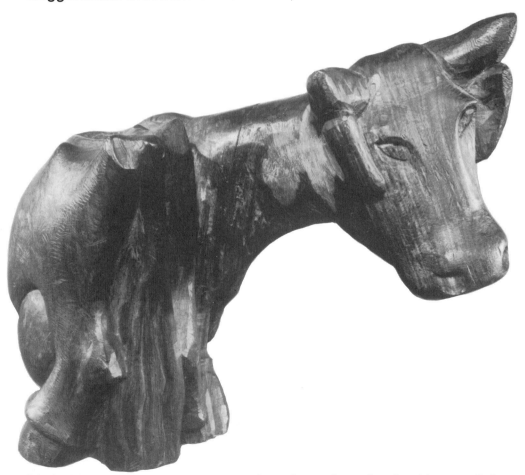

COW, 1928. "I made things in wood, taking a lump of wood and making very little alteration in its shape — just enough to turn it into something different."

designing a black mobile for the museum. He sent word that he wanted it made out of gold. Sandy's reply: "All right, I'll make it of gold but I'll paint it black." Another architect commissioned a small sculpture for the corner of his dining room, but that wasn't Sandy's idea for the space. He made an object that filled the whole corner and trailed across the ceiling, taking over the whole room. (You may have noticed that I mostly use the word "object" or "work" for Sandy's sculptures. He preferred this because "then a guy can't come along and say, 'No, those aren't sculptures.' It washes my hands of having to defend them.")

Sandy made some beautiful wood constructions in the 1940s that he called *Constellations.* He said that they "had for me a specific relationship to the *Universe* I had done in the early 1930s." If you look at the *Constellation* shown here — which hangs on a wall — then at the wire *Universe,* you'll see what he meant. And we know by now that in Sandy's work one thing often led directly to another.

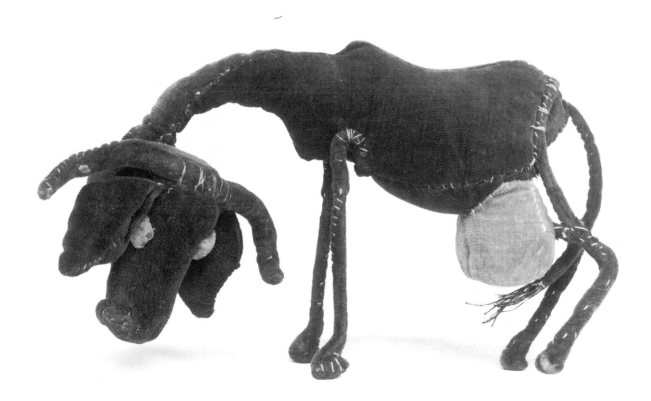

COW from the Circus, 1926–31. "The cow is a languid, long-suffering animal."

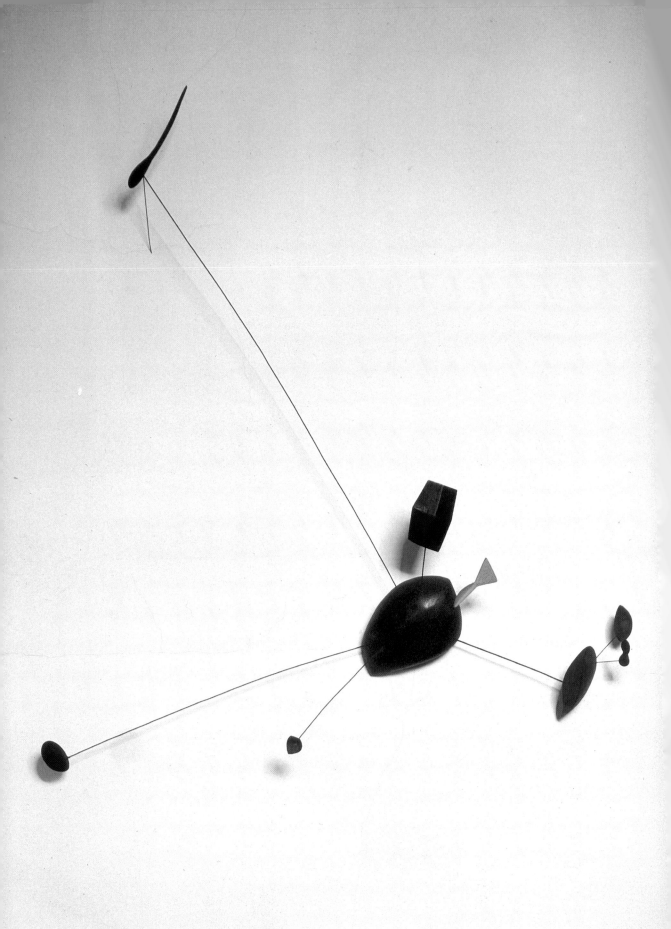

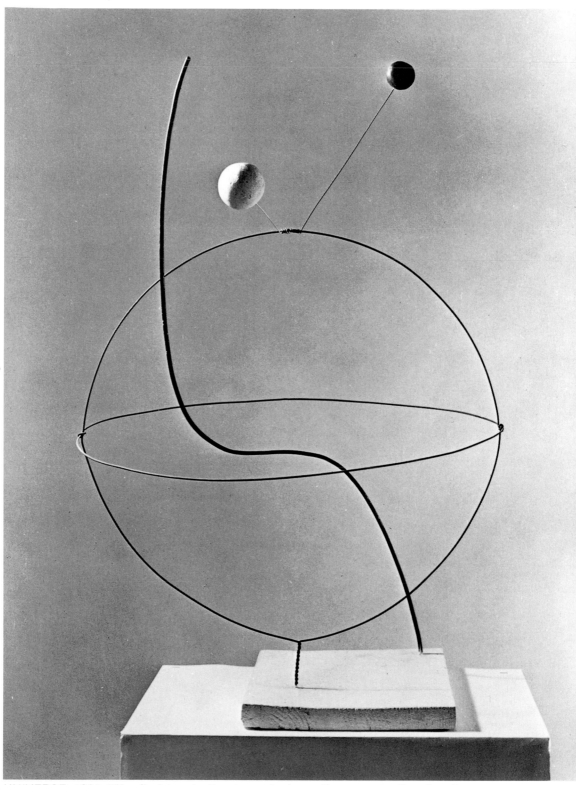

UNIVERSE, 1931. "The first inspiration I ever had was the cosmos, the planetary system."

◄CONSTELLATION, about 1943. "I was interested in the extremely delicate open composition."

BRONZE

In 1930 Sandy was living in Paris, and a foundry that cast bronze sculptures from clay models was nearby. He found it easy to experiment with bronze and made a cow, a cat, a horse, and, besides a number of other figures, a weight lifter who looks as if he were related to the Circus strongman, Rigoulot. One that is particularly interesting, shown here, is a woman balancing on a heavy cord, like a circus tightrope performer.

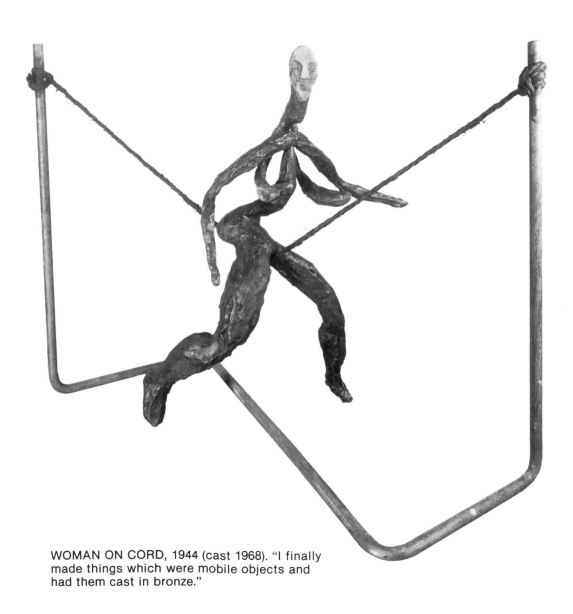

WOMAN ON CORD, 1944 (cast 1968). "I finally made things which were mobile objects and had them cast in bronze."

WIRE

You can see here a wire portrait of Josephine Baker, a famous black jazz singer whom Sandy admired when he saw her perform in Paris in the 1920s. He made several other wire portraits of Josephine Baker; they are especially interesting because they are something like mobiles. As the flexible wire figure hangs from a thread, any breeze moves her hands and feet and spiral breasts as if she were performing. Sandy said he had always worked with the idea of making things move, even his wire figures, and at home he liked to hang them from the ceiling.

Sandy's best drawings look as if his lines were pieces of thin wire, twisted to make the drawing: see *On the High Wire* and a wonderful wirelike portrait of the famous philosopher Jean-Paul Sartre, both on page 74. Sandy's wire sculptures, like the five-foot circus balancing act (called *The Brass Family* because it was made of brass wire) are among his liveliest, most original work. Some of his simple abstract wire sculptures, like *The Pistil,* are really beautiful, and his wire animals are both handsome and amusing. The *Cow* is in a way a funny kind of mobile: When you turn her head, the long wire that goes to her tail lifts the tail and that makes the spiral brass turd plop off its hook to the ground. This cow is related to one of the Circus animals that Peggy remembers Sandy gave his nephew, "a blue velvet cow with a soulful expression who turned her head when her red velvet udders were pulled." Sandy had a lot of fun thinking those up!

A famous printmaker, Stanley William Hayter, remembered a time in Paris — in 1927 — when he and Sandy were visiting José de Creeft, a sculptor friend. Sandy went off to the kitchen with his pliers and some wire, and after a time called them to come see what he had done. He had made a wire dog and fastened its hind leg to the faucet, so that when the water was turned on the dog lifted his leg.

In the early days, Sandy sometimes went to the gallery that was selling his work carrying his shears and pliers and a roll of wire over his shoulder, as you see him here. Then right on the spot he made a whole show of wire sculptures.

He once told his sister, Peggy, "I think best in wire."

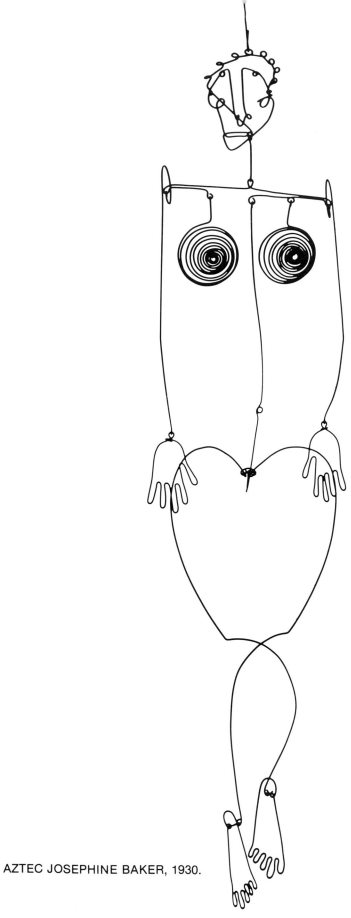

AZTEC JOSEPHINE BAKER, 1930.

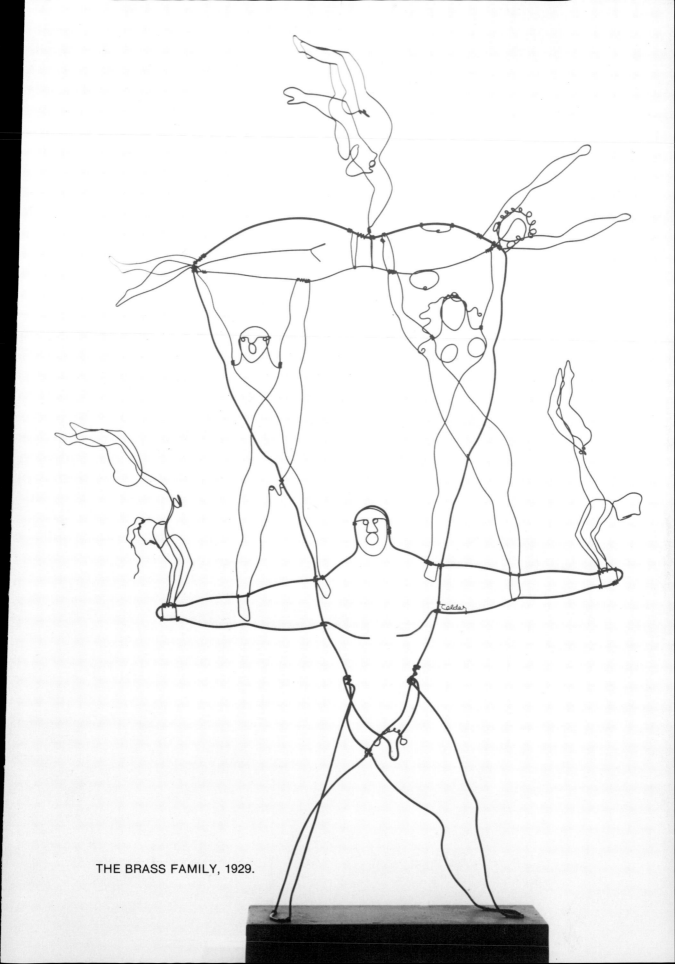

THE BRASS FAMILY, 1929.

SPRING, 1928.

"[For the Guggenheim Museum exhibition] I even undid an old bale of wire I had had in storage since 1929, and took out *Spring* and *Romulus and Remus*. I'd always thought these particularly humorous, but now they looked like good sculpture."

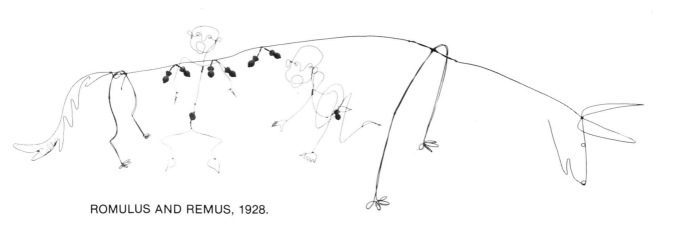

ROMULUS AND REMUS, 1928.

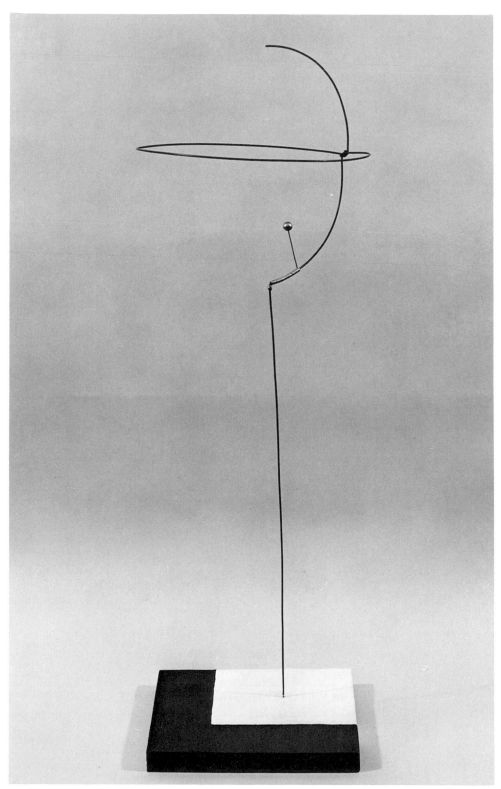

THE PISTIL, 1931. "My entrance into the field of abstract art came as the result of a visit to the studio of Piet Mondrian in Paris in 1930."

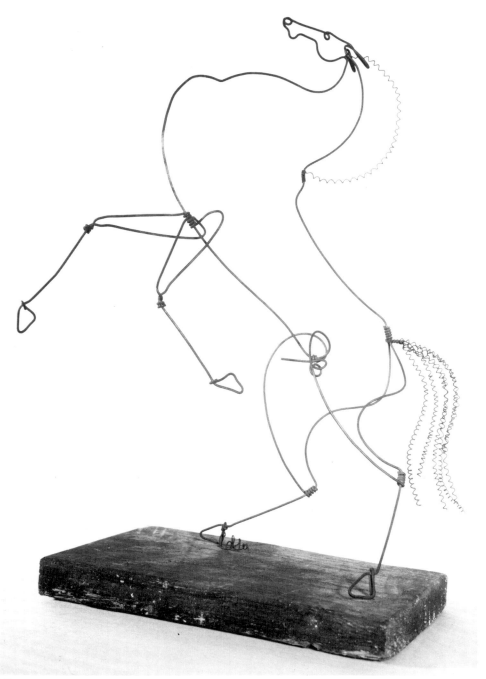

REARING STALLION, about 1928.

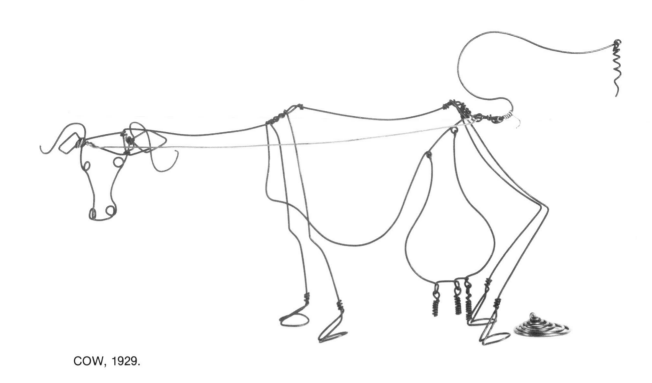

COW, 1929.

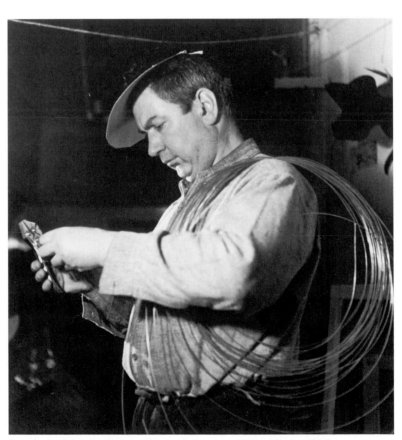

Sandy in his studio on Second Avenue, New York, 1938.

EXPERIMENTS WITH MOTORS

Before Sandy made his first wind mobile in 1932, he experimented with several kinds of moving sculpture, beginning with a wire goldfish tank, with wire fish that swam back and forth at the turn of a tiny crank. These mechanical works were exhibited in Paris, and were named "mobiles" by the artist Marcel Duchamp. Now that word is used only for the sculptures that move freely in the air, without cranks or motors.

Sandy had always been interested in motors, but he got tired of the motorized works because there were no surprises. They always repeated themselves, and he was annoyed when motors broke down. They were "too painful — too many bugaboos," so he invented mobiles that moved by themselves. These became his favorite works; he said that he made about two thousand of them.

However, about forty-five years after he had experimented with his first motor-driven works, he designed his greatest one for the Sears Tower lobby in Chicago. It's fifty-five feet long, and has seven separate motors to make the various elements perform at different speeds. In action, *Universe* looks like a ballet. The performers, whose movements suggest those of suns and moons, are some of the shapes Sandy liked best — circles and spirals and triangles; and their colors are those he used for all his work: bright red, yellow, orange, blue, and black.

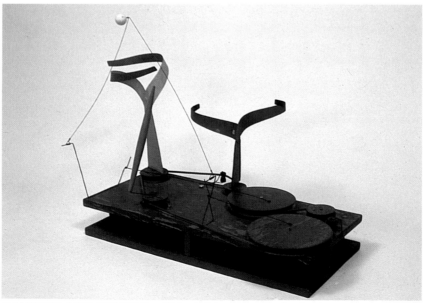

DANCERS AND SPHERE, 1936. "With a mechanical drive, you can control the thing like the choreography in a ballet."

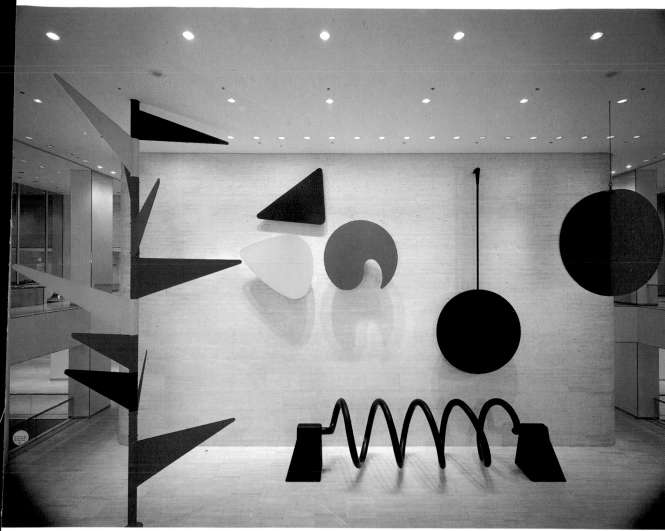

UNIVERSE, 1974. "The underlying sense of form in my work has been the system of the Universe."

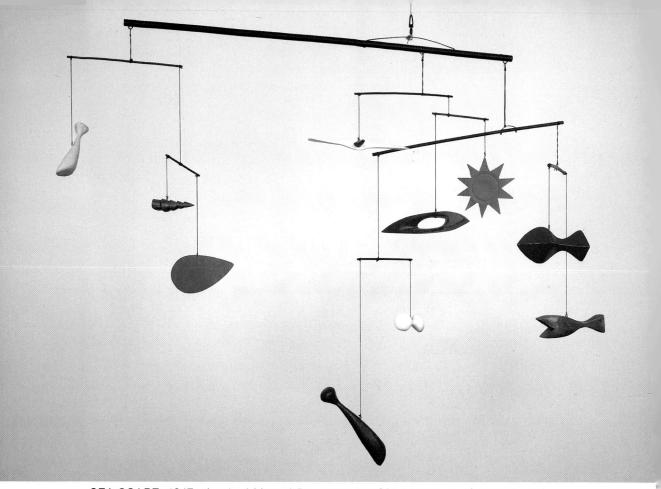

SEA SCAPE, 1947. "I asked Marcel Duchamp in 1931 what sort of name I could give these things and he at once produced 'Mobile.'"

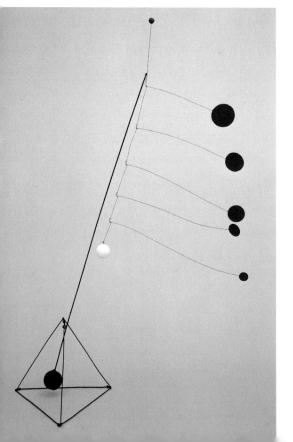

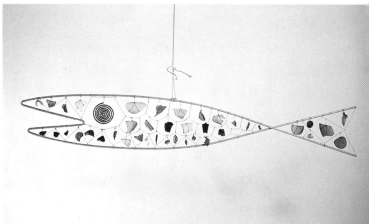

FISH, 1948–50. "I feel an artist should go about his work simply with great respect for his materials."

CALDERBERRY BUSH, 1932. "Why must art be static? The next step is sculpture in motion."

THOUSANDS OF MOBILES

Sandy said that both the moving toys in his Circus and his training in engineering got him interested in the idea of motion as an art form. The way he became interested in abstract art is told in his *Autobiography.* When he first settled in Paris, a great Dutch painter who lived there, Piet Mondrian, invited him to visit his studio. Sandy liked Mondrian's colored rectangles—the red, yellow and blue that have come to be known as "Calder colors" —and when he saw some pieces of colored cardboard tacked on Mondrian's walls, he suggested that "perhaps it would be fun to make these rectangles oscillate." This was the origin of the Calder mobiles.

The first mobiles, like *Sea Scape,* often had pieces of carved wood hung on wires or bits of colored glass or pottery from Sandy's collection of scraps. Later mobiles were made entirely of metal painted in the primary colors, red, yellow, and blue, with black and white, and orange once in a while. These were the simple colors Sandy came to like best, with red and black his favorites for both mobiles and stabiles. The latest, largest mobiles were made of steel (the biggest, for the National Gallery of Art, of aluminum), and parts moved up and down as well as around to make more complicated patterns in space. Because they are so heavy, they move much more slowly than the small mobiles, and so the various movements aren't hard to follow.

Artists' works are now often so large that they need to have metal shops enlarge them from small handmade models. The biggest mobiles were first made for Sandy in a blacksmith's shop and later in metal shops—one in Tours, near his house in Saché, France, and three near his Roxbury, Connecticut, house.

Sandy explained several times, very simply, how he planned his mobiles and how he got them to balance. "I start by cutting

out a lot of shapes. Next I file them and smooth them off. Some are bits I just happen to find. Then I arrange them on a table with wires between the pieces for the overall pattern. Finally I cut some more on them with my shears, calculating for balance this time." He told, another time, how he managed the balancing problem: "You put a disc here and then you put another disc at the other end and then you balance them on your finger." And still another time, "I begin with the smallest and work up. Once I know the balance point for this first pair of discs, I anchor it by a hook to another arm, where it acts as one end of another pair of scales, and so on up."

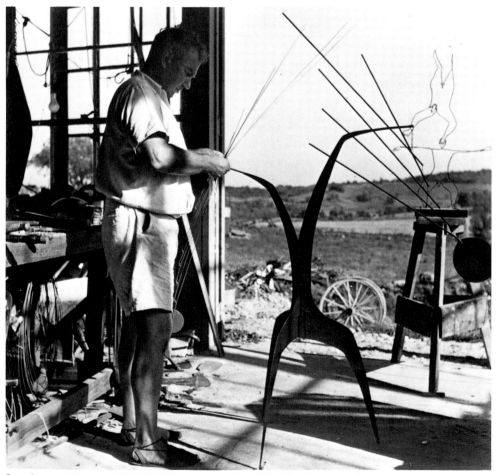

Sandy working on EFFET DU JAPONAIS in his Roxbury studio about 1945.

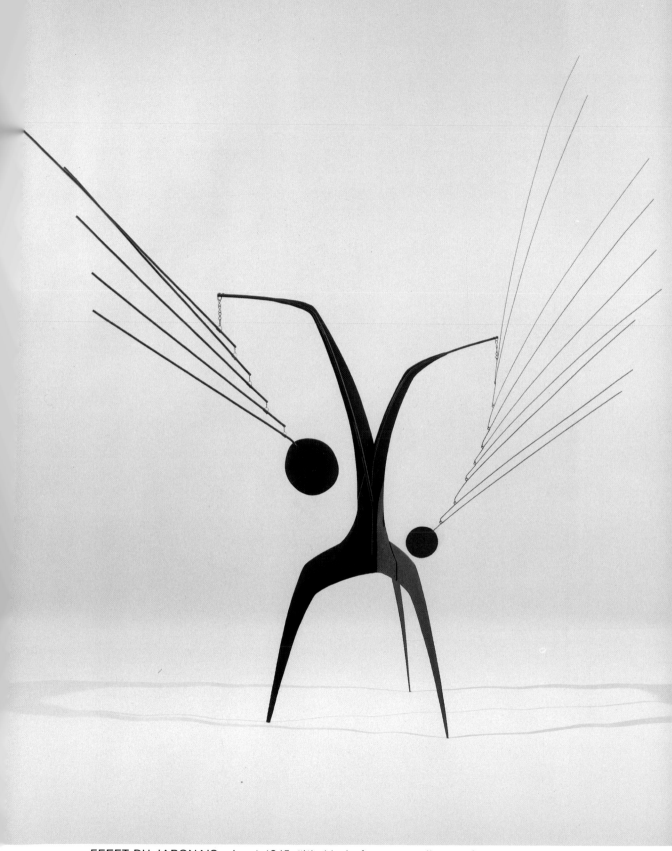

EFFET DU JAPONAIS, about 1945. "It's kind of an ascending scale
of weights and counterweights."

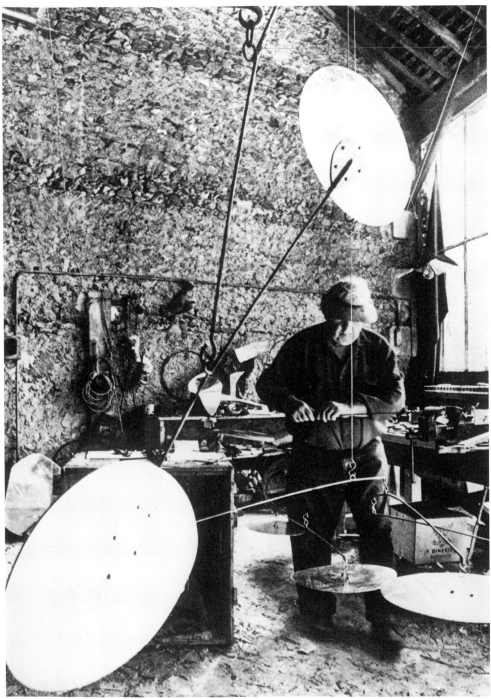

Sandy assembling a mobile in his Saché studio, 1965. "I have a cardboard visor. I look for it when I arrive in the shop. That ties in with what I was doing yesterday."

Sandy made his mobiles simply, with simple tools. He always carried a few small tools with him when he traveled so that he could set up a workshop anywhere. Once on a brief visit to India he made eleven mobiles and stabiles and some gold jewelry. He said that he deliberately avoided using power tools, in spite of having been trained as an engineer, though for the largest mobiles the foundry workmen needed to. All the mobiles were made to be taken apart easily; flattened out they can be mailed or shipped in surprisingly small packages. The smallest were made to fit into envelopes.

The never-failing Calder playfulness and humor are noticeable even in his totally abstract kind of work, where only shapes and colors seem to be the subject. James Johnson Sweeney said that all the poetry of Calder's work has its source in play: "He plays with forms, colors, lines, movements." The mobiles always move with gaiety, and they sometimes do amusing things. In a group named *Gongs,* polished brass pieces make a ringing sound when they are struck by other parts of the mobile. In the mobile illustrated, the heavy yellow rod strikes the brass gong.

One of the first works that could be called a mobile, made in 1930, is just nine red metal saucers of different sizes set on the ground, above which a white wood ball and a black iron ball are hung on wires. When the heavy iron ball is given a push, the

UNE BOULE NOIRE, UNE BOULE BLANCHE, 1930 (reconstructed 1969).

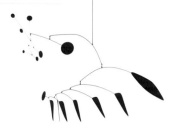

lighter wooden one skips from saucer to saucer, making different sounds when it hits different-size plates. Sometimes it bounces around for quite a while, making a little tune. Sandy was pleased when some wind mobiles made surprising sounds too. He also liked the shadows mobiles make as they move in front of a light.

For Sandy's later mobiles, though some of them were still about real things, like an elephant or a cat, or kept the idea of real things, like suns and moons, or snowflakes or spiders, it was the abstract shapes and colors, and especially movement, that he cared about most. He said one time, "Just as one can compose colors, or forms, so one can compose motions." His titles often give us clues to what he was thinking when he made a mobile. He did often start off with an idea of some real thing, even when the finished work seems to have no real subject. "When I have used spheres and discs," he said, "I have intended that they should represent something more—the earth is a sphere. The sun is a sphere."

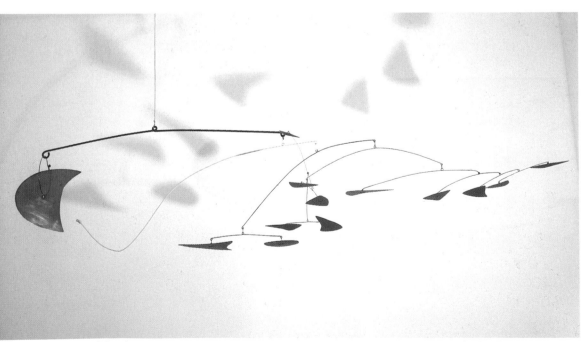

GONG, 1957. "I like the 'whang' they make—noise is another whole dimension."

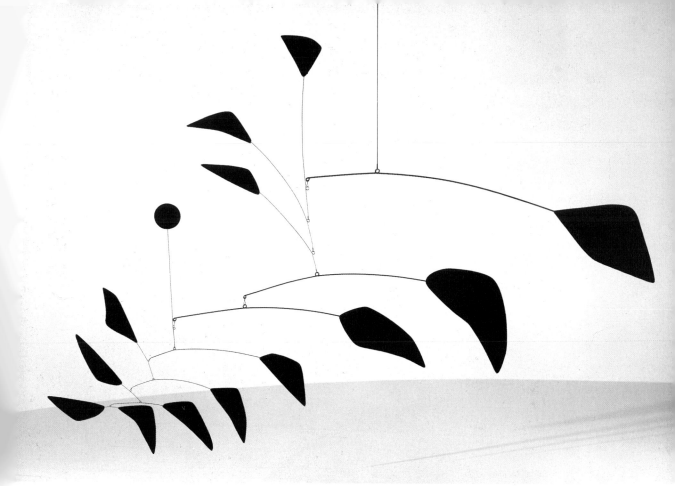

BIG RED, 1959. "I love red so much that I almost want to paint everything red."

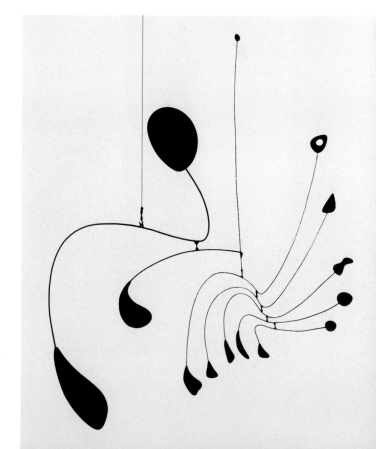

HANGING SPIDER, about 1940.
"A mobile is a very modest thing."

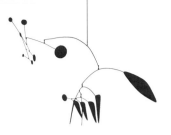

There are three kinds of mobiles, and here you can see some of each: those that stand, those that are made to be attached to walls and, most numerous, interesting, and beautiful, those that hang from ceilings in people's houses and in public places like banks, airports, and museums. The hanging mobiles are what most people think of when anyone mentions America's greatest sculptor, Alexander Calder. The one that everyone looks at now in the National Gallery in Washington is the biggest. You can imagine from the picture how it looks when it moves slowly in all directions around its enormous space. But Sandy liked one of his smallest standing mobiles too; see him blowing to make it spin as he holds it gently in his hand.

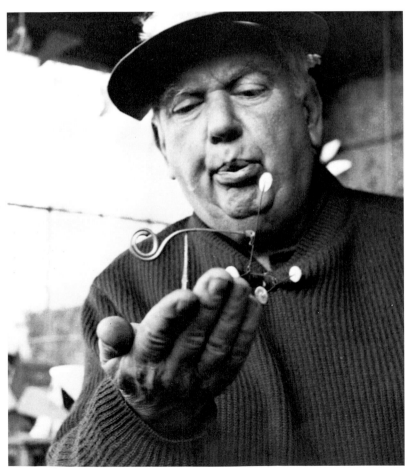

Saché, 1965.

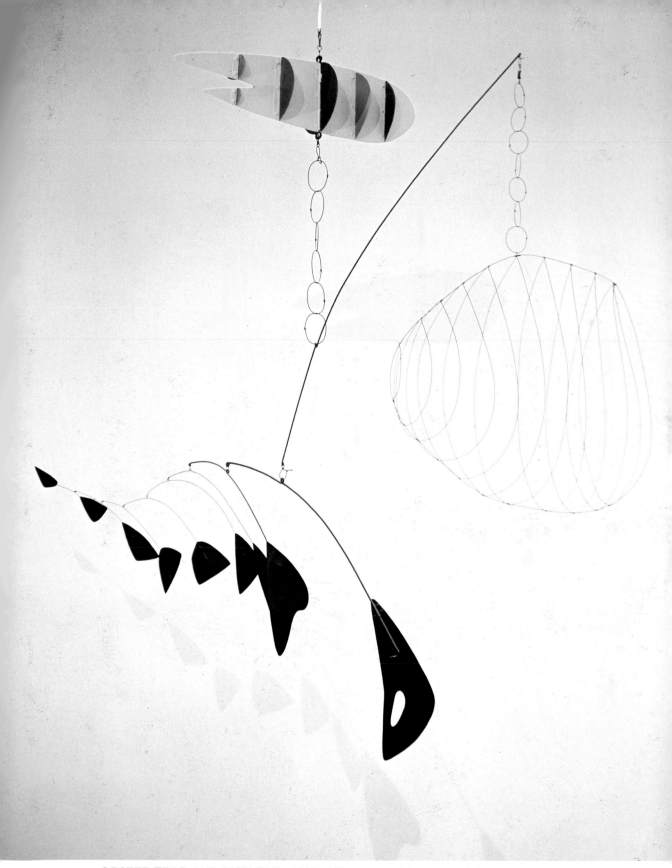

LOBSTER TRAP AND FISH TAIL, 1939. "When everything goes right a mobile is a piece of poetry that dances with the joy of life and surprises."

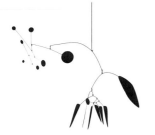

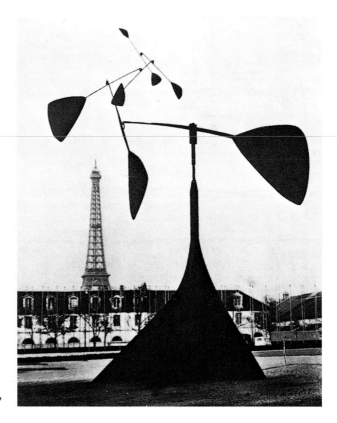

SPIRALE, 1958. "It goes up, it's something like a flame."

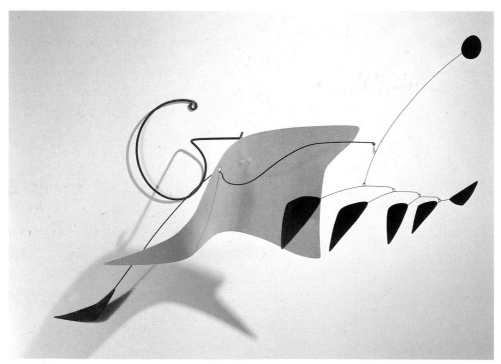

YELLOW WHALE, 1958. "Disparity in form, color, size, weight, motion, is what makes a composition."

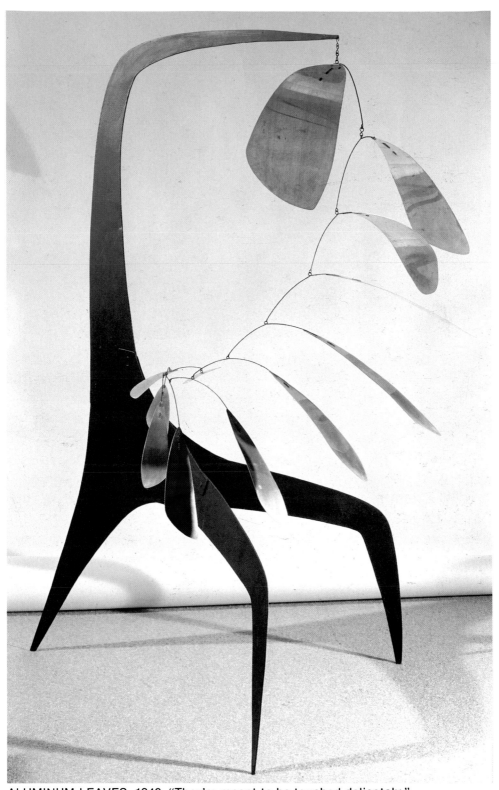

ALUMINUM LEAVES, 1940. "They're meant to be touched delicately."

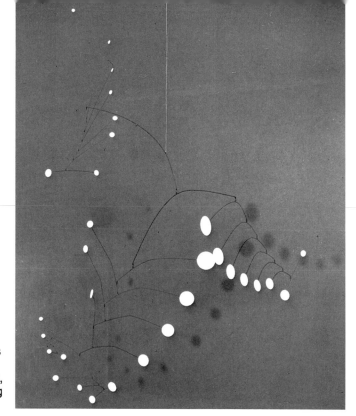

SNOW FLURRY, I, 1948.
"The round white disc is pretty much a standard thing in life — snowflakes, money, bubbles, cooking devices."

People who write and talk about the mobiles often use the same words to describe them: joyous, jaunty, surprising, dancing, active, colorful, graceful — but the words "lively" and "magical" come up most often. As the mobiles move freely in a breeze they do seem to be magical creatures, full of life. An English artist, Ben Nicholson, borrowed a Calder mobile to hang from the ceiling of his room in Paris, overlooking the Seine River, and wrote about it: "This mobile object turned slowly in the breeze in the light of an electric bulb hung near its center — a large black, six white, and one small scarlet, balls on their wires turned slowly in and out, around, above and below one another, with their shadows chasing round the white walls in an exciting inter-changing movement, suddenly hastening as they turned the corners and disappearing, as they crossed the window, into the night — it was alive like the hum of the city, like the passing river and the smell of Paris in early spring, but it was not a work of art as many people think of a work of art — imprisoned in a gold frame or stone-dead on a pedestal in one of our marble-pillared mausoleums [he means museums]. But it was 'alive' and that, after all, is not a bad qualification for a work of art."

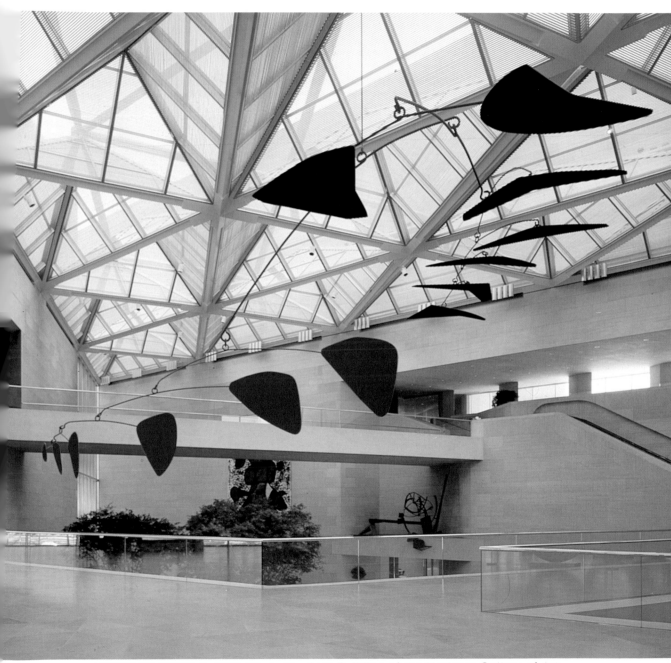

UNTITLED MOBILE, 1973–77, in the East Building of the National Gallery of Art, Washington, D.C. "People think that monuments should come out of the ground, never out of the ceiling, but mobiles can be monumental, too."

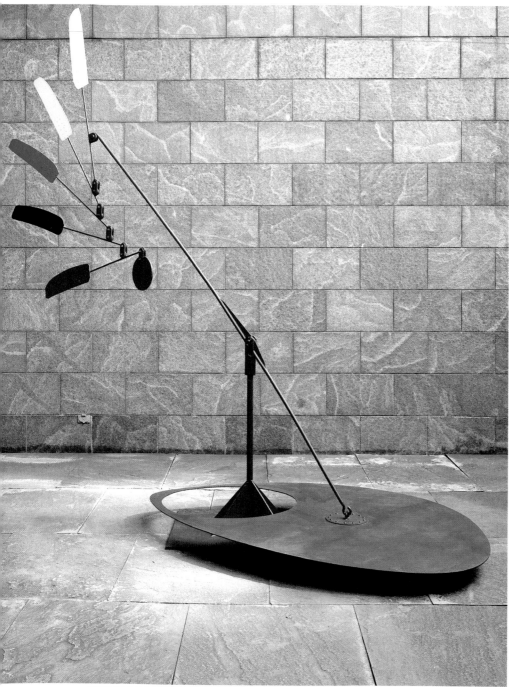

INDIAN FEATHERS, 1969. "About my method of work:
first it's the state of mind. Elation."

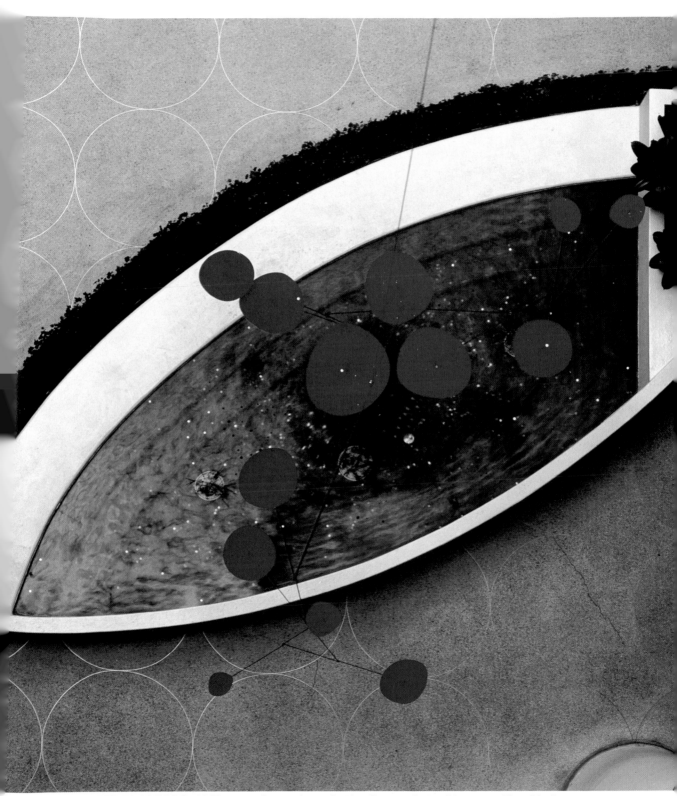

RED LILY PADS, 1956, seen from above in the Guggenheim Museum, New York.
"To most people who look at a mobile, it's no more than a series of flat objects
that move. To a few, though, it may be poetry."

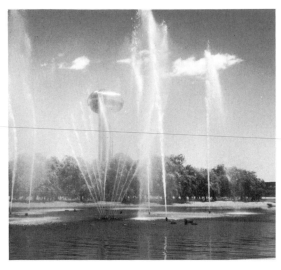

BALLET OF
SEVEN SISTERS, 1956.

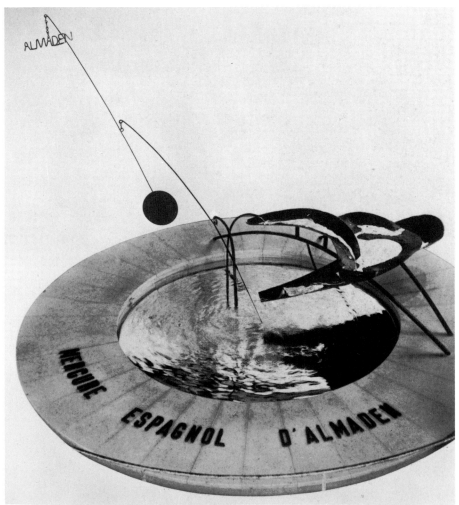

MERCURY FOUNTAIN, 1937.

OTHER ACTIVE WORKS

FOUNTAINS

In 1937 Sandy made a mercury fountain for the Spanish Pavilion at the Paris Exposition, designed to promote the mercury from the mines of Almadén. It was a challenging experiment engineered with the constant Calder interest in inventive movement, and was related to his early mobiles. He explained in his *Autobiography* how the mercury circulated underground and "was pumped up thirty inches where it spewed onto an irregularly shaped dish of iron, lined with pitch. This dish was very nearly horizontal, otherwise the mercury would have rushed off. It trickled in turn onto another plate, differently shaped, and then from that onto a chute which delivered it rather rapidly against a sort of bat, attached to the lower end of a rod, which held at the upper end another rod — with a red disc at the bottom and in hammered brass wire the word ALMADEN on top. The impact of mercury against the bat made the combination of the two rods, the red disc, and the word 'Almaden' weave in the air in a sort of figure eight."

In 1939 Sandy designed a water ballet with fourteen jets, fifty feet high, for the New York World's Fair. It was never carried out, but in the mid-1950s he made a similar fountain group that was programmed to perform through various cycles. It was called *Ballet of Seven Sisters* and is at the General Motors Technical Center near Detroit.

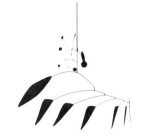

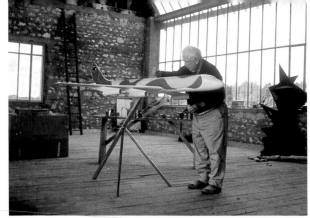

Sandy painting a model plane for Braniff, Saché, 1973.

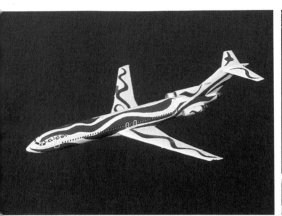

FLYING COLORS OF THE UNITED STATES, 1975.

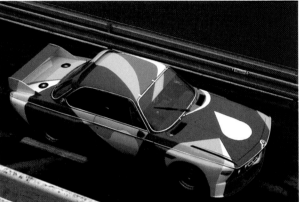

BMW-CALDER, 1975. "You should know how to get the best out of leisure; it's a stimulating atmosphere for invention."

JET PLANES

When his art dealer told Sandy that Braniff Airlines wanted him to paint a jet, he said, "It might be fun. I'll see what I can come up with." The three Braniff jets that he designed in Calder colors could be looked at as giant, mobile paintings. When you see them in flight, they look like huge, colorful, plane-shaped Calder sculptures. On the sides of the planes, the Calder signatures are about fifteen feet long.

A RACING CAR

The *BMW-Calder,* a car painted by Sandy, competed in a race at Le Mans, France, in 1975. After being exhibited at the Louvre in Paris and at the Whitney Museum in New York, it was installed in the BMW Museum in Munich.

MOVING STAGE SETS

Sandy designed stage sets for more than a dozen kinds of theatrical productions, and the costumes as well as the sets for several of the performances. The stage sets were always planned with some kind of movement, and actual mobiles were an important part of the design for a number of ballets and plays. An unusual production, titled *Calder Piece,* starred a large standing mobile, on which four percussion musicians performed by striking it. Another exciting performance was *Work in Progress,* Sandy's own nineteen-minute "ballet" in which the performers were mobiles and stabiles, seen against huge colored backdrops. It was produced at the Rome Opera House in 1968, accompanied by electronic music.

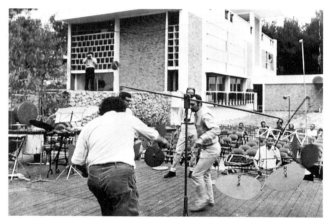

Rehearsal of
CALDER PIECE, 1967.

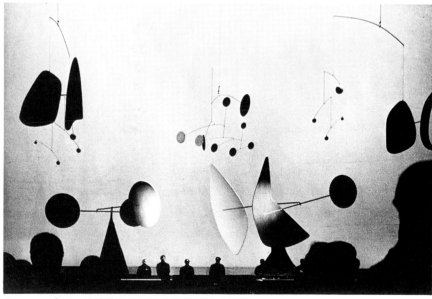

A scene from WORK IN PROGRESS, 1968.

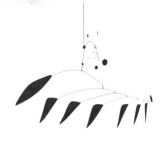

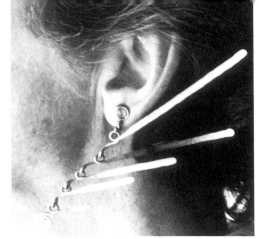

EARRING, 1953.

MOBILE JEWELRY

The first wire jewelry Sandy made was for Peggy's dolls, and from then on he twisted jewelry out of wire—mostly brass but also other kinds of metal, including gold and silver. The wire jewelry often held "jewels" of carefully selected bits of scrap; some of them, like large chunks of obsidian and optical glass, are very beautiful. Sandy made a wire necklace with pieces of blue pottery for his mother for her birthday. He made Louisa's engagement ring of gold, a copper wire wedding ring for a friend, an aluminum pin in the shape of a hand for another friend. Sandy liked to play on people's names, as in a fish pin for Cordelia Pond and a hawk for Frances Hawkins. A specially interesting kind is mobile jewelry: miniature mobiles as earrings, a bracelet with a dozen mobile units that quiver as they dangle from their metal rings, and necklaces made of spirals that swing gently with every movement.

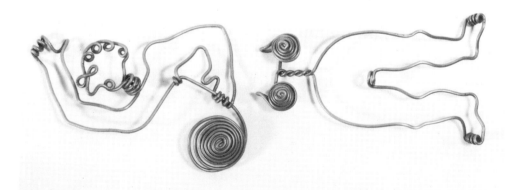

BELT BUCKLE, about 1935, shown unfastened and fastened.

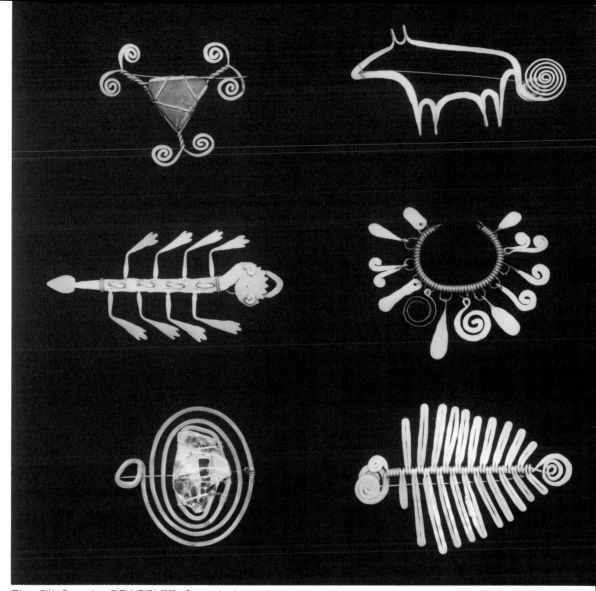

Five PINS and a BRACELET. One pin is a pig, one an alligator;
one displays a piece of glass and one a stone.

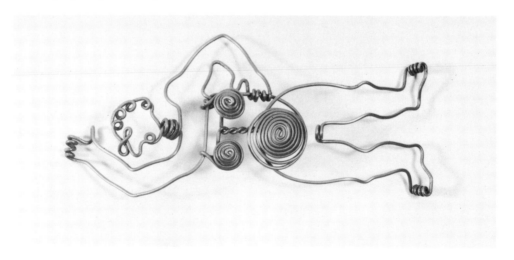

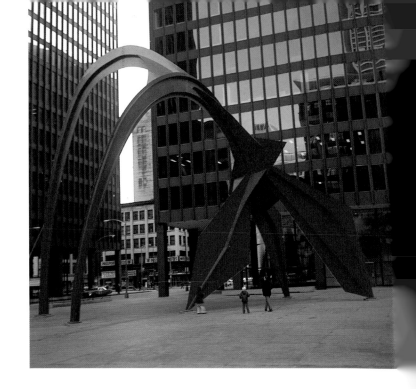

FLAMINGO, 1974. "Red because the piece is set against a black glass building."

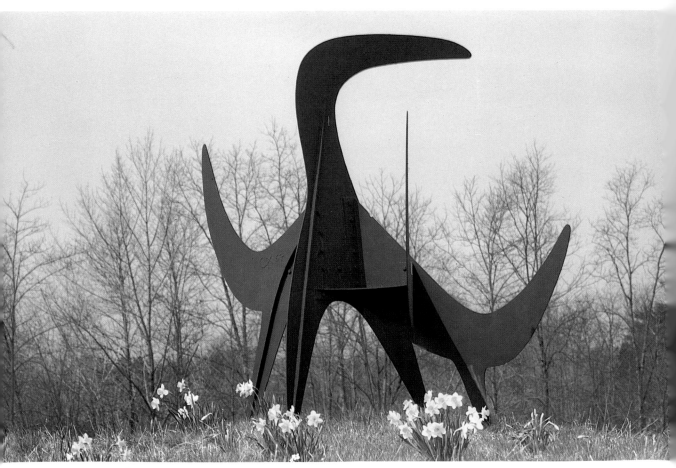

LONGNOSE, 1957. "When I use two or more sheets of metal cut into shapes mounted at angles to each other, I feel that there is a solid form."

STABILES

Calder stabiles, which can now be seen in public places all over the world, seem to be the exact opposite of the mobiles. They are certainly stable instead of moving, but even so there is always a sense of movement in their design. The stabiles range in size from a few feet to close to a hundred; over the years Sandy made them larger and larger. Almost all of them were painted solid black or red with the same flat paints used for the mobiles. Red was Sandy's favorite color, and he usually wore a red flannel shirt for work, or even for times when other people dressed up. Getting back to the idea of motion in the stabiles, let's look at some of them.

Longnose wasn't meant to look like a bird or even a birdman but, large and heavy though it is, it could have just landed lightly in the field of daffodils. Here is Calder magic for sure.

Flying Dragon is certainly a plane, just about to take off.

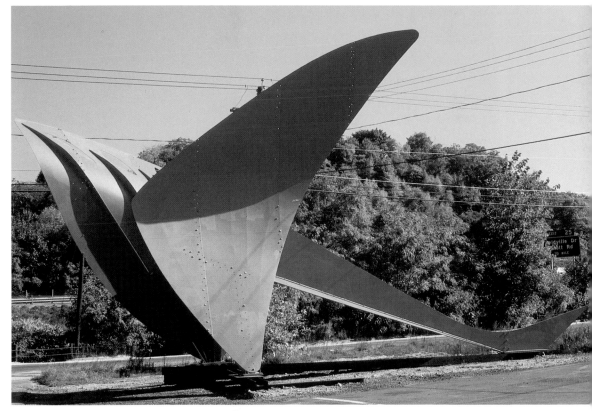

FLYING DRAGON, 1975. "Jean Arp said to me, 'What were those things you did— stabiles?' Whereupon I seized the term."

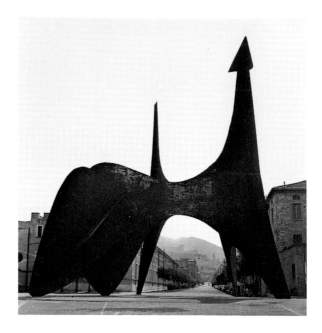

TEODELAPIO, 1962. "People keep giving it a phallic meaning. I wasn't aware of any such influence, but that may give it its nice force."

Teodelapio, named after a duke of Spoleto, acts as a gateway to that Italian town. As one walks or drives through or around it, it looks entirely different from each side. Huge, obviously weighing tons, it still seems to be moving with you.

Like the mobiles, the stabiles were designed to be taken apart easily for shipping, so that they are, in another sense, mobile — like mobile homes. Even the very large ones travel to museums for exhibitions. Because the parts are bolted together, never welded, taking them apart and reassembling them is easy.

The word *easy* is significant. Making stabiles or mobiles, or anything else, Sandy kept everything as simple as possible. For the small stabiles, he cut strips of sheet aluminum with shears. Then he punched holes for the bolts, shaped the pieces in a vise between blocks of wood, filed the edges smooth, and bolted them together. He worked rapidly, without hesitation, always knowing exactly what he was doing, so it all looked easy.

The big stabiles were made in the same metal shops as the large mobiles. Sandy provided scale models, made the same way he himself made the small stabiles. Skilled metal workers machine-cut plates of heavy steel that were then curved between rollers and lifted by cranes to be put together with bolts. Metal ribs and gussets were welded on whenever needed to give

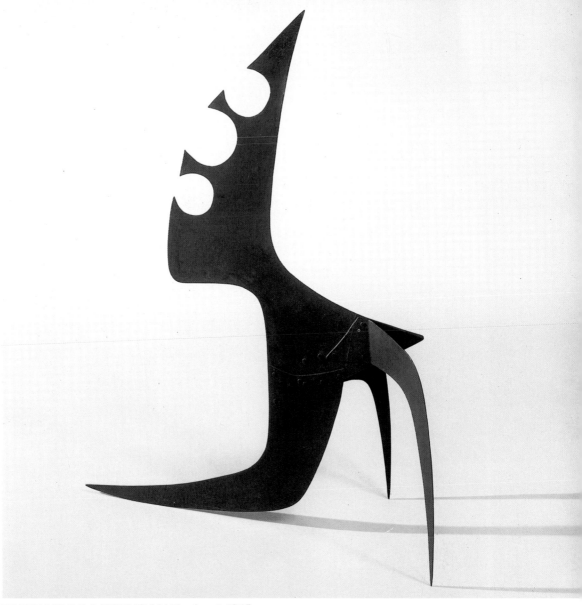

PORTRAIT OF A YOUNG MAN, about 1945.

stability. The dotted pattern of the bolts and the lines of the ribs add lively surface interest to the plain steel plates that make up the stabiles.

Sandy is best known for his mobiles, but the great red or black stabiles are magical too. Walking around a Calder stabile in a city square is an exciting experience. The stabiles seem to be in motion because the angles and curves keep changing to form different shapes with every step one takes. The chances are that you'll come across at least one in many of the big cities that you visit.

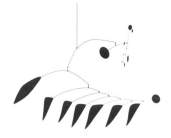

Sandy and his grandson Sandy Rower watching the installation of LE GUICHET at Lincoln Center, New York, 1965. A maquette for the stabile, whose title translates as *Box Office,* stands between them.

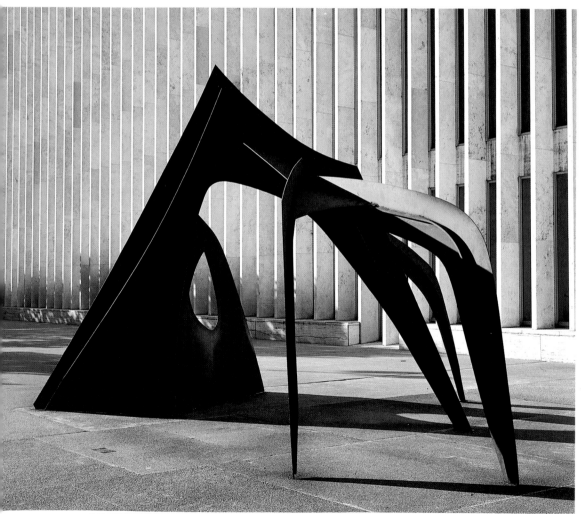

LE GUICHET, 1963. "I make a little maquette of sheet aluminum. With that I'm free to add a piece, or to make a cutout. When the enlargement is finished, I add the ribs and the gussets."

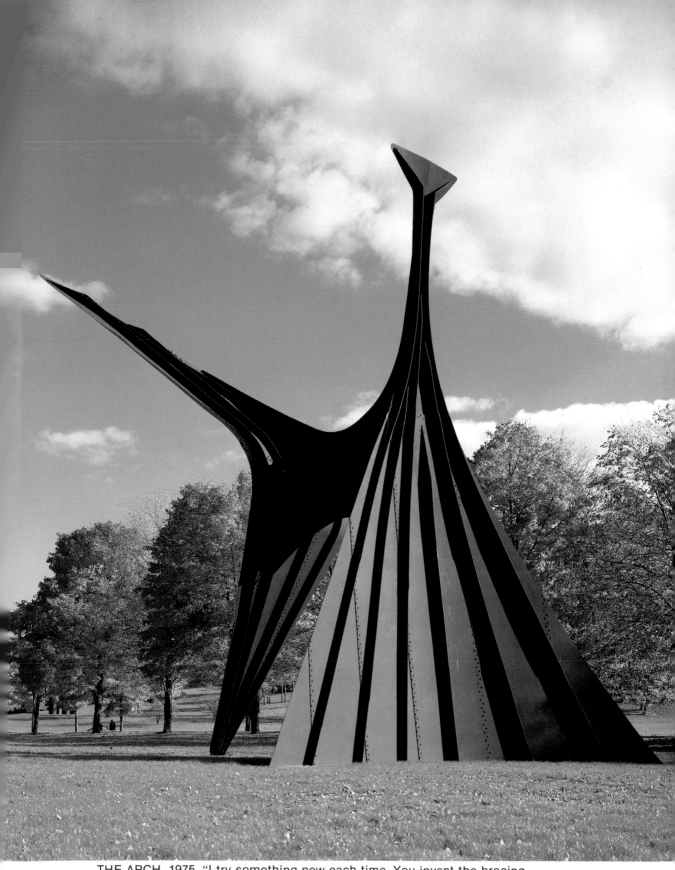

THE ARCH, 1975. "I try something new each time. You invent the bracing as you go, depending on the form of the object."

ON THE HIGH WIRE, 1932.

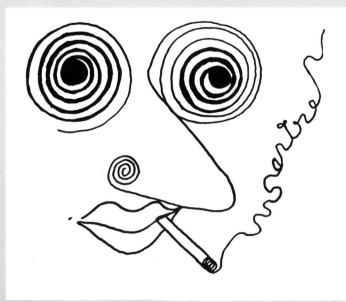

SARTRE WITH CIGARETTE, 1947. "When you have
no workshop you can always draw."

EVERY KIND OF ART

DRAWINGS

Drawing was how Sandy had begun his life as an artist. After graduating from Stevens Institute of Technology in 1919, he did drafting work in an engineer's office in New York, and went to a public night-school class in elementary charcoal drawing. Later, when he studied at the Art Students League, he drew and drew — even while riding on the subway to and from class.

On pages 20–21 we saw a few drawings he did in the zoo. Here we see a circus drawing that he did after he went to Paris, where he again attended drawing classes. He also drew portraits of his friends, like the one of Jean-Paul Sartre, whose name blows out of his cigarette.

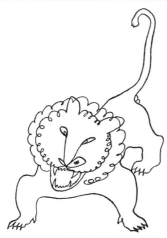

A GNAT CHALLENGES A LYON

AS a lyon was blustering in the forrest, up comes a gnat to his very beard, and enters into an expostulation with him upon the points of honour and courage. What do I value your teeth, or your claws, says the gnat, that are but the arms of every bedlam slut? As to the matter of resolution; I defy ye to put that point immediately to an issue. So the trumpet sounded and the combatants enter'd the lists. The gnat charged into the nostrils of the lyon, and there twing'd him, till he made him tear

13

LYON, in *Fables of Aesop*. "Caricature the action as well as the animal."

MANY, 1931.

A remarkable group of drawings he did in 1931 was exhibited not long ago as *Space Drawings.* They are all astonishingly simple, some just showing the sun and two thin lines to represent a mountain or the horizon, or simply the sun and moon. In the one reproduced here, there are also a number of planets. This drawing makes it easy to imagine that the little black circles could come together as parts of a Calder mobile.

Everything Sandy did is related in some way, and while his drawings seem totally different from mobiles, they really are not. Sandy drew all his life, and often began making the mobiles by drawing outlines on the metal sheets. When you see a real mobile in motion you will notice how it draws patterns in the air.

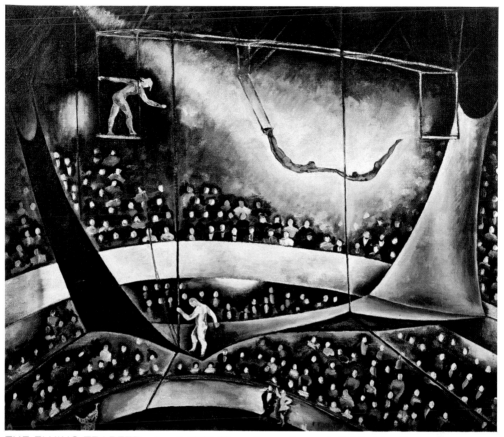

THE FLYING TRAPEZE, about 1925. "I've always been delighted by the ways things are hooked together. It's just like a diagram of force. I love the mechanics of the thing—and the vast space—and the spotlight."

PAINTINGS

Sandy made quite a few oil paintings, like *The Flying Trapeze,* when he first began to study art. Most of his paintings, however, were done in gouache—opaque rather than transparent watercolor. At his home in France, in addition to his big sculpture studio, Sandy had a separate small painting workshop that he called his *gouacherie.* He greatly enjoyed painting gouaches, and in his last years did many hundreds of them, one or more almost every day. He said, "I very much like making gouaches. It goes fast and one can surprise oneself."

Many of the gouaches are about people and animals, and others represent the universe. Some are simply designs. Occasionally Sandy named these after he had finished them and found they looked like something; *Contour Plowing,* done as a gouache and then as a print, is one of these. His gouaches are all done in bright, flat colors, straight from the jar, similar to the colors he painted his sculptures. He said, "My idea is to make a painting in which the gaiety of colors produces a real shock."

AIX, 1953. "I did some large human heads with stripes.
I seemed to develop something new."

BIG BUG, 1970.

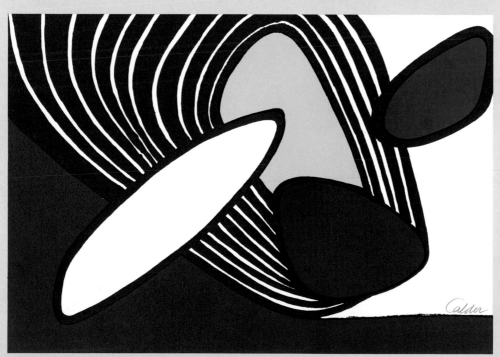

CONTOUR PLOWING, 1974. "Sometimes it's the whole thing that suggests a title to me, sometimes it's just a detail."

YELLOW EQUESTRIENNE, 1975.

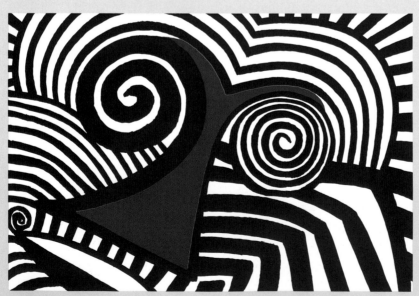

THE RED NOSE, 1969. "I have chiefly limited myself to the use of black and white as being the most disparate colors. Red is the color most opposed to these."

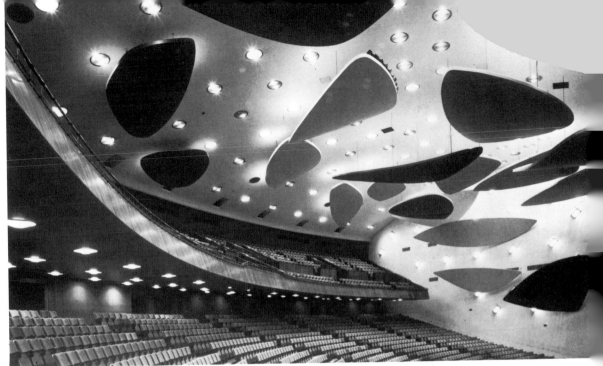

ACOUSTIC CEILING, Aula Magna, Caracas, Venezuela, 1952. "[The acoustical engineer] kept saying: 'The more of your shapes, the merrier and the louder.' Apparently the acoustics are very successful."

AND, AND, AND...

Sandy became more and more interested in abstract design. Many of his gouaches, lithographs, posters, tapestries, and rugs, as well as mobiles and stabiles, don't portray scenes or objects from the real world; they are just about themselves. He did a huge rooftop painting in Grand Rapids; a black-and-white patterned sidewalk in front of the Perls Galleries in New York; two colored wallpaper designs that were also printed on cloth. A very ambitious work was an acoustic ceiling for an auditorium in Caracas, Venezuela. Sandy had met the Venezuelan architect Carlos Raúl Villanueva and saw him again in 1952. In his *Autobiography,* Sandy recalled: "[Villanueva] was doing an auditorium and wanted me to do something for the lobby, a mobile.

"I said, 'I'd rather be in the main hall.'

"And he said, 'Oh! No! You can't do that because the ceiling is taken up with ribbons of acoustical reflectors.'

"I said, 'Let's play with these acoustical reflectors.' And I made him a sketch. We drew large round and oval shapes, some of them to be thirty feet or so long, painted different colors, and hung from the ceiling on cables from winches. There were also some of these shapes on the side walls."

STABILES poster, 1963.

COVER for *Art in America* magazine, October 1964.▶

Art in America

Calder

SERVING FORKS, about 1940.

The greatest contrast with this monumental public work is the group of simple household objects Sandy made for his homes, and for friends. There are large serving spoons he made by simply cutting and folding sheet aluminum. The silver forks reproduced here look quite a lot like his silver wire jewelry. He also made lighting fixtures of pierced tin, garbage pails painted in camouflage patterns, tin-can unspillable ashtrays, carved wooden fingers to hold toilet-paper rolls, and dozens of other inventive objects. A newspaper reporter called Sandy's many unique objects *whatchama-Calders,* an amusing catch-all name for the unclassifiable new things Sandy thought up and made.

SPLOTCHY wallpaper, 1949.

GREEN BALL tapestry, 1971.

UNIVERSE rug, 1976–77. "The basis of everything for me is the universe."

RUG, 1965. "I seem to remember animals rather well.
I used to draw them in the Central Park Zoo."

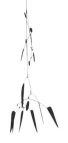

A great many of the homemade gadgets were planned as gifts, such as a mobile *Birthday Cake* — a candle in a tin can topped by four mobiles — for his mother's ninetieth birthday. Sandy was unusually generous with the objects he created. Many of his friends have jewelry he made and gave them, or wonderful drawings and gouaches, or his books with personal inscriptions. He even gave away small mobiles simply as an expression of friendship and affection, almost as if the objects themselves were of little importance. He also gave quite a number of his most important works to museums, and designed prints to be sold to raise money for various worthy causes. Sandy and Louisa Calder were actively interested in political and social affairs and were always ready to support causes they felt strongly about. One example: They were opposed to American involvement in Vietnam; in 1972, well before the Watergate impeachment furor, they sponsored an ad in the *New York Times* calling for President Nixon's removal from office because his conduct of the Vietnam War was unconstitutional.

Many famous artists and art critics wrote about Calder during and after his lifetime. Among them was Robert Osborn, the cartoonist, a close friend, who wrote the page opposite when Sandy was seventy-seven years old.

Sandy Calder was first of all an artist, but he was also an engineer and, always, an inventor. Everything he began in what seemed to be the usual way ended up being different from anything that had ever been done before. He started each project as a fresh, challenging experiment, with a happy confidence that it would succeed. He was rarely disappointed and never discouraged; he once said, "Sometimes [when I'm not satisfied] I intend to destroy one of my works, but then I improve it." Whenever we look at one of his objects we somehow feel the sense of adventure and enjoyment that he had in making it. And it's exciting to share the daring imagination that is a part of everything Sandy made. This is the magic in the mix that held together all his various talents and made him the great, spellbinding artist he was.

One can't compress Sandy
into a few words./ Too much
of him !....too large....and his
qualities are too varied & contra-
dictory. Engineer-Artist. /Capricious
yet totally logical. A serious
Santa Claus./Mobile as a dream,,
..stabile as the very earth, & some-
times both./ A lover of fun, full
of wit & play, but confronted by
things evil he is as grim a
battler as one could ask for./He
is that rare combination of de-
light & POWERS with which he
has blessed us all.

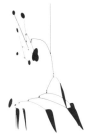

WHERE TO SEE SOME CALDER MOBILES AND STABILES

In almost every one of the biggest cities in the world, it is worth asking in the museums you visit that include contemporary art whether there is a work by Calder on view. The chances are that there will be. The big mobiles and stabiles in museums and public places are especially interesting, and they are easy to locate. Here is a sampling of some of them, several of which are illustrated in this book.

Asterisks next to titles indicate works that are mobiles. The others listed are stabiles.

Several museums, such as the Museum of Modern Art and the Whitney Museum of American Art in New York and the Centre National d'Art et de Culture Georges Pompidou in Paris, have large collections of Calder's work in various mediums that he used. His Circus and the film *Calder's Circus* can be seen on the main floor of the Whitney Museum.

In the United States

Albany, New York—Empire State Plaza, *Triangles and Arches*
Bloomington—University of Indiana, *Peau Rouge, Indiana*
Cambridge—Massachusetts Institute of Technology, *La Grande Voile*
Chicago—Federal Center Plaza, *Flamingo*
Dallas—Dallas-Fort Worth Airport, *Red, Black and Blue**
Des Moines, Iowa—American Republic Insurance, *Spunk of the Monks*
Detroit—Michigan Bell Telephone Building, *Jeune Fille et Sa Suite*
Fresno, California—*Bucephalus*
Grand Rapids, Michigan—Calder Plaza, *La Grande Vitesse*
Hartford, Connecticut—Alfred E. Burr Mall, *Stegosaurus;* Connecticut Bank and Trust Company, *Mobile**
Houston—Museum of Fine Arts, *The Crab*
Los Angeles—Security Pacific National Bank, *Four Arches*
New Haven, Connecticut—Yale University, *Gallows and Lollipops*
New York City—Chase Manhattan Bank, 410 Park Avenue, *Untitled mobile*;* Guggenheim Museum, *Five Red Arcs*, Red Lily Pads*;* John F. Kennedy International Airport, *.125*;* Lincoln Center for the Performing Arts, *Le Guichet;* Metropolitan Museum, *Red Gongs*;* Museum of Modern Art, *Black Widow, Lobster Trap and Fish Tail*, Morning Star, Snow Flurry, I*;* Whitney Museum of American Art, *Bifurcated Tower*, Big Red*, Fish*, Indian Feathers*, Roxbury Flurry*, Sea Scape**

Philadelphia—Penn Center Plaza, *Three Discs, One Lacking;* Philadelphia Museum of Art, *Ghost**
Pittsburgh, Pennsylvania—Greater Pittsburgh Airport, *Pittsburgh**
Poughkeepsie, New York—Vassar College Art Gallery, *The Circle**
Princeton, New Jersey—Princeton University, *Five Discs, One Empty*
Purchase, New York—Pepsico, *Hats Off*
Washington, D.C.—National Gallery of Art, Untitled mobile*
Wichita, Kansas—Fourth National Bank and Trust Company, *Eléments Démontables**

Around the world

Montreal, Canada—*Man*
Mexico City, Mexico—Aztec Stadium, *El Sol Rojo*
Caracas, Venezuela—Museo de Bellas Artes, *The City*
Humlebaek, Denmark—Louisiana Museum, *Slender Ribs*
Grenoble, France—Railroad Station, *Les Trois Pics*
Paris, France—Centre National d'Art et de Culture Georges Pompidou, *Nageoire, 31 Janvier*;* Rond Point de la Défense, *L'Araignée Rouge;* UNESCO, *Spirale**
Saché, France—*Totem-Saché*
Saint-Paul, France—Fondation Maeght, *Une Boule Noire, une Boule Blanche**
Frankfurt, Germany—U.S. Consulate, *Hextoped*
Hannover, Germany—Opera House, *The Halebardeer*
Spoleto, Italy—*Teodelapio*
Rotterdam, Netherlands—*Tamanoir*
Sydney, Australia—Australia Square, *Crossed Blades*

MORE TO READ ABOUT CALDER'S LIFE AND WORK

The following three books were the main sources for this book:

Calder, Alexander. *Calder: An Autobiography with Pictures.* Pantheon, New York, 1966; paperback reprint, Beacon, Boston, 1969. Calder tells about his life from early childhood to 1966.

Hayes, Margaret Calder. *Three Alexander Calders.* Paul S. Eriksson, Middlebury, Vermont, 1977. An illustrated family memoir; Sandy's sister describes his development from inventive child to inventor of the mobile.

Lipman, Jean. *Calder's Universe.* Viking Press in cooperation with the Whitney Museum of American Art, 1976, reprinted 1980. Presents outstanding examples of the many kinds of art that Sandy made throughout his life; served as catalogue for the last major exhibition of his work during his lifetime; contains extensive descriptive bibliography.

Four of the nine books that Calder illustrated have been reprinted and can be found in bookstores, museums, and libraries:

Animal Sketching, 1926. Paperback reprint, Dover, New York, 1973. An art instruction book with text and brush drawings by Calder.

Fables of Aesop, According to Sir Roger L'Estrange, 1931. Paperback reprint, Dover, New York, 1967. Drawings by Calder.

Selected Fables by Jean de La Fontaine, 1948. Paperback reprint, Dover, New York, 1968. Etchings by Calder.

Three Young Rats and Other Rhymes, 1944. Reprint, Museum of Modern Art, New York, 1946. Introduction by James Johnson Sweeney, drawings by Calder.

Other interesting publications about Sandy Calder, available in large libraries:

Alexander Calder: A Retrospective Exhibition. Guggenheim Museum, New York, 1964. Catalogue of a major exhibition of 287 works.

Davidson, Jean. "Four Calders." *Art in America* magazine, vol. 50, no. 4 (Winter 1962) Family history, by Calder's son-in-law, illustrated with works by Calder, his grandfather, father, and daughter.

Lipman, Jean, with Nancy Foote. *Calder's Circus.* E. P. Dutton with the Whitney Museum of American Art, New York, 1972. Circus figures photographed for this book, stills from the *Calder's Circus* film, and photographs of many Calder works related to the Circus.

Mulas, Ugo, and Arnason, H. Harvard. *Calder.* Viking Press, New York, 1971. Dramatic photographs of Calder's work, with large details; text by Arnason about the artist's career.

Osborn, Robert. "Calder's International Monuments." *Art in America* magazine, vol. 57, no. 2 (March/April 1969). Interview with Calder about his stabiles, with descriptions and photographs of 21 of them.

Sweeney, James Johnson. *Alexander Calder.* Museum of Modern Art, New York, 1951. Updated edition of the catalogue of the first major museum exhibition of Calder's work in 1943.

Sweeney, James Johnson. "Alexander Calder: Work and Play." In *What Is American in American Art.* McGraw-Hill, New York, 1963; originally published in *Art in America* magazine, vol. 44, no. 4 (Winter 1956/57). Fascinating discussion of the importance of play in Calder's work.

"A Visit with Calder." *Look* magazine, December 9, 1958. Interesting description of how Calder made a mobile.

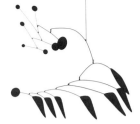

LIST OF WORKS ILLUSTRATED

page 40 bottom
Romulus and Remus, 1928
Wire, wood, 9 feet 4 inches long
The Solomon R. Guggenheim Museum,
New York

page 41
The Pistil, 1931
Wire, brass, wood, 40 inches high
Whitney Museum of American Art, New York;
gift of the Howard and Jean Lipman
Foundation, Inc. (and purchase)

page 42
Rearing Stallion, about 1928
Wire, 22¾ inches high
Collection of Mr. and Mrs. Klaus G. Perls,
New York

page 43 top
Cow, 1929
Wire, 16 inches long
The Museum of Modern Art, New York;
gift of Edward M. M. Warburg

page 44
Dancers and Sphere, 1936
Painted sheet metal, wood, wire, motor, 17¾
inches high
Galerie Maeght, Zurich

page 45
Universe, 1974
Painted stainless-steel plate, aluminum plate,
motors, 33 feet high
Sears Tower, Chicago

page 46 top
Sea Scape, 1947
Painted wood, sheet metal, string, wire, 60
inches wide
Whitney Museum of American Art, New York;
gift of the Howard and Jean Lipman
Foundation, Inc. (and purchase)

page 46 bottom left
Calderberry Bush, 1932
Painted sheet metal, wood, wire, rod, 7 feet
high
Collection of Mr. and Mrs. James Johnson
Sweeney, New York

page 46 bottom right
Fish, 1948–50
Glass, wire, 60 inches long
Collection of Louisa Calder,
Roxbury, Connecticut

page 49
Effet du Japonais, about 1945
Painted sheet metal, rod, wire, 54 inches high
Collection of Rev. and Mrs. Howard Rower,
New York

page 51
Une Boule Noire, une Boule Blanche, 1930
(reconstructed 1969)
Painted metal, wood, wire, rod, 8 feet high
Fondation Maeght, Saint-Paul, France

page 52
Gong, 1957
Brass, painted sheet metal, rods, 8 feet wide
Collection of Mr. and Mrs. Joel W. Harnett,
New York

page 53 top
Big Red, 1959
Painted sheet metal, wire, 9 feet 6 inches wide
Whitney Museum of American Art, New York;
gift of the Friends of the Whitney Museum of
American Art

page 53 bottom
Hanging Spider, about 1940
Painted sheet metal, wire, 51 inches high
Collection of Mrs. John B. Putnam,
Cleveland, Ohio

page 55
Lobster Trap and Fish Tail, 1939
Painted sheet metal, wire, 9 feet 6 inches wide
The Museum of Modern Art, New York;
gift of the Advisory Committee

page 56 top
Spirale, 1958
Painted steel plate, rod, 16 feet 5 inches high
UNESCO, Paris

page 56 bottom
Yellow Whale, 1958
Painted sheet metal, wire, 45 inches wide
Collection of Howard and Jean Lipman,
New York

page 57
Aluminum Leaves, 1940
Painted sheet metal, sheet aluminum, wire, 61
inches high
Collection of Howard and Jean Lipman,
New York

page 58
Snow Flurry, I, 1948
Painted sheet metal, wire, 7 feet 10 inches
high
The Museum of Modern Art, New York;
Mrs. Simon Guggenheim Fund

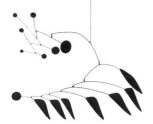

page 59
Untitled mobile, 1973–77
Painted aluminum honeycomb, wire, rods, 60
feet wide
National Gallery of Art, Washington, D.C.;
gift of the Collectors Committee

page 60
Indian Feathers, 1969
Painted sheet metal, rod, 11 feet 4¾ inches
high
Whitney Museum of American Art, New York;
gift of the Howard and Jean Lipman
Foundation, Inc.

page 61
Red Lily Pads, 1956
Painted sheet metal, metal rods, wire, 16 feet 9
inches wide
The Solomon R. Guggenheim Museum,
New York

page 62 top
Ballet of Seven Sisters, 1956
Programmed fountain designed for General
Motors Technical Center, Warren, Michigan

page 62 bottom
Mercury Fountain, 1937
Steel rod, sheet steel surfaced with pitch,
mercury, 8 feet 6 inches high
Designed for Spanish Pavilion, Paris Exposition

page 64 center left
Flying Colors of the United States, 1975
Specially formulated aerospace paint on
727–200 jet, 153 feet long
Braniff International

page 64 center right
BMW-Calder, 1975
Automotive paints on BMW 3.0 CSL
BMW Museum, Munich, Germany

page 65 top
Calder Piece, composed by Earle Brown
Played on the Calder mobile, *Chef d'Orchestre,*
1967
Rehearsal for performance by Diego Masson's
orchestra at the Théâtre de l'Atelier, Paris

page 65 bottom
Work in Progress, 1968
Stage set and mobiles for a ballet without
dancers
Presented at the Rome Opera House

page 66 top
Earrings, 1953
Gold, 1½ inches high
Collection of Leslie Stillman,
Litchfield, Connecticut

pages 66–67 bottom
Belt buckle, about 1935
Brass, 8 inches long
Whitney Museum of American Art, New York;
gift of Mrs. Marcel Duchamp
in memory of the artist

page 67 top
Clockwise from top left:
Pin, about 1960
Brass, silver, stone, 4½ inches wide
Pig pin, about 1930–40
Brass, 6½ inches long
Bracelet, about 1930–40
Brass, silver, 2½ inches diameter
Pin, about 1930–40
Brass, 6½ inches wide
Glass pin, about 1930–40
Zinc, brass, optical glass, 4½ inches wide
Alligator pin, about 1930–40
Silver, 7 inches long
All collection of Jean Lipman, New York

page 68 top
Flamingo, 1974
Painted steel plate, 53 feet high
Federal Center Plaza, Chicago

page 68 bottom
Longnose, 1957
Painted steel plate, 8 feet 2 inches high
Collection of Howard and Jean Lipman,
New York

page 69
Flying Dragon, 1975
Painted steel plate, 56 feet long
Mobil Oil Corporation, Fairfax, Virginia

page 70
Teodelapio, 1962
Painted steel plate, 59 feet high
Spoleto, Italy

page 71
Portrait of a Young Man, about 1945
Painted sheet metal, 35¼ inches high
Collection of Howard and Jean Lipman,
New York

page 72 bottom
Le Guichet, 1963
Painted steel plate, 22 feet wide
Lincoln Center for the Performing Arts,
New York; gift of Howard and Jean Lipman

page 73
The Arch, 1975
Painted steel plate, 56 feet high
Estate of Alexander Calder; courtesy
M. Knoedler & Co., Inc., New York

page 74 top
On the High Wire, 1932
Ink on paper, 20½ x 24⅞ inches
Whitney Museum of American Art, New York;
promised gift of Howard and Jean Lipman

page 74 bottom
Sartre with Cigarette, 1947
Ink on paper, 4½ x 6 inches
Formerly collection of Charles Alan, New York

page 75
Lyon, in *Fables of Aesop, According to Sir
Roger L'Estrange*
Drawings by Calder
Published by Harrison of Paris [Monroe
Wheeler and Barbara Harrison], 1931
Paperback reprint, Dover, New York, 1967

page 76
Many, 1931
Ink on paper, 19⅝ x 25½ inches
The Museum of Modern Art, New York;
gift of Mr. and Mrs. Klaus G. Perls

page 77
The Flying Trapeze, about 1925
Oil on canvas, 36 x 42 inches
Estate of Alexander Calder; courtesy
M. Knoedler & Co., Inc., New York

page 78
Aix, 1953
Gouache on paper, 29 x 43 inches
Collection of Sandra Davidson, Saché, France

page 79 top
Big Bug, 1970
Gouache on paper, 29 x 43 inches
Whitney Museum of American Art, New York;
promised gift of Howard and Jean Lipman

page 79 bottom
Contour Plowing, 1974
Color lithograph, 26⅜ x 38 inches
Whitney Museum of American Art, New York

page 80 top
Yellow Equestrienne, 1975
Gouache on paper, 23 x 30⅝ inches
Collection of Mr. and Mrs. A. R. Landsman,
New York

page 80 bottom
The Red Nose, 1969
Color lithograph, 29⅜ x 42⅝ inches
Whitney Museum of American Art, New York;
promised gift of Howard and Jean Lipman

page 81
Acoustic ceiling, 1952
Painted plywood, largest element 30 feet wide
Aula Magna, University City, Caracas

page 82
Stabiles, 1963
Poster, 25½ x 19½ inches
Galerie Maeght, Paris

page 83
Cover for *Art in America* magazine,
October 1964

page 84
Serving forks, about 1940
Silver wire, 8–13 inches long
Collection of Louisa Calder,
Roxbury, Connecticut

page 85
Splotchy, 1949
Wallpaper designed for
Laverne Originals, New York

page 86
Green Ball, 1971
Aubusson tapestry, 79 x 54½ inches
Collection of Shirley Polykoff, New York

page 87 top
Universe rug, 1976–77
Wool, 58 x 43 inches
Made by Jean Lipman

page 87 bottom
Untitled rug, 1965
Wool, 66 x 82 inches
Made by Leslie Stillman

PHOTO CREDITS

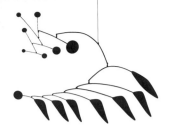

INDEX OF PEOPLE
MENTIONED IN THIS BOOK